POSTCARD HISTORY SERIES

Huntington Beach

POSTCARD HISTORY SERIES

Huntington Beach

Marvin Carlberg and Chris Epting

ARCADIA
PUBLISHING

Published by Arcadia Publishing
Charleston SC, Chicago IL, Portsmouth NH, San Francisco CA

Printed in the United States of America

Library of Congress Control Number: 2008933392

For all general information contact Arcadia Publishing at:
Telephone 843-853-2070
Fax 843-853-0044
E-mail sales@arcadiapublishing.com
For customer service and orders:
Toll-Free 1-888-313-2665

Visit us on the Internet at www.arcadiapublishing.com

Thanks to mom and dad for your encouragement and support.
—Marvin

To Jean, Charlie, Claire, and mom—hope you enjoy this celebration of our adopted city.
—Chris

CONTENTS

ACKNOWLEDGMENTS

Unless otherwise noted, the postcards pictured in this book are from the personal collection of Marvin Carlberg. Thanks to fellow deltiologists (postcard collectors) for helping fill in the gaps and share some of their postcards as well: Aaron Jacobs, Randy and Sharon Lynn, Ronn Rathbun, and Charles Sanders.

Postcard publishers:
The Benham Company, Los Angeles
Columbia International, North Hollywood
Dexter Press, West Nyack, New York
Frashers Fotos, Pomona
Gilmore Photo Laboratory, San Pedro
Golden West Photo, Long Beach
Hitchcock Photo
Mitock and Sons, North Hollywood
Newman Post Card Company, Los Angeles
Walt M. Reeves, Los Angeles
M. Rieder, Los Angeles
Rigdon's Pharmacy, Huntington Beach
The Rotograph Company, New York
Royal Photo, Colton
Curt Teich and Company, Chicago
Western Publishing and Novelty Company, Los Angeles
Wood's Print, Los Angeles

PREFACE

It is fascinating to look at these old postcards and see what Huntington Beach was like 100, 50, or even 25 years ago. I grew up in Huntington Beach when it was a small town with miles of undeveloped open space, strawberry fields, and Ed's Dairy, which had real cows. The Pacific Coast Highway skyline was filled with a large number of oil derricks, many more than are seen today. I remember some of them were painted like bucking broncos, siphoning their oil riches from great underground pools. Main Street today is barely recognizable from what it was not too many years ago.

I have collected postcards for as long as I can remember. My grandfather was a civil engineer who traveled around the world designing improved water treatment facilities in developing countries. He would send picture postcards from these faraway lands, places I had never heard of but wanted to learn more about.

The first postcard I remember getting of Huntington Beach was a promotional one from the Beef Palace, an amazing butcher shop near where I lived as a child. It had two life-sized fiberglass cows out front that my mom would let me "ride" while she was shopping inside. The owner somehow found out I liked postcards and gave me one from the stack on top of the counter that I could look up to but couldn't reach. I still shop there today. The employees are consistently knowledgeable and friendly. I wish that there were more fine family businesses like it still in Huntington Beach.

In building my postcard collection, it was hard to find old cards of Huntington Beach in Huntington Beach. I figure this is because most postcards are either mailed out of town or carried back home to friends and family. I scour the vintage collectable paper shows around Southern California and am thrilled when I make a new discovery. And the Internet has been a tremendous resource connecting collectors with postcard sellers around the country and world.

Working on this book has been a great experience and has given me the excuse to do some local sightseeing and visit some corners of the city that I had never explored before. Many of the historic buildings pictured in this book are long gone, but others remain, and some have been repurposed.

Looking at these postcards brings back such great memories of the old days in Huntington Beach when times were quieter and there was more open space and agriculture. Some images are familiar, yet they are different today. For example, pictured in the book is Huntington Beach High School as it looked in 1926, long before I graduated from there. It has mostly retained its original look, yet it definitely has changed throughout the years. Many of the original school buildings were damaged in the 1971 Sylmar earthquake and rebuilt to modern standards, but they lack the character of the original style.

We have included excerpts from some of the original messages found on the postcards when they were mailed, messages that give an extra dimension and flavor of the time period. I hope you enjoy browsing through the images in this book and that it brings back some happy memories of your own, whether you live in Huntington Beach or are just passing through.

—Marvin Carlberg

INTRODUCTION

Huntington Beach has always been sort of a "postcard city." Going back more than 100 years that people have lived and visited here, its unique location and near-perfect climate have created the ideal backdrop for photographers and artists, and the results over the years have been spectacular (as documented in the images contained in this book).

A brief history of Huntington Beach goes back to when it was a 30,000-acre Spanish land grant when the Stearns Rancho Company ran cattle and horses and raised barley on what is now the city. Around 1890, it was called Shell Beach before becoming Pacific City in 1901 when P. A. Stanton formed a local syndicate and bought 40 acres along the beach. In 1904, the town name was changed to Huntington Beach in honor of H. E. Huntington, who sponsored the extension of the Pacific Electric Railway to the seaside village.

Incorporated in 1909, Huntington Beach remained a quiet seaside town until the famous oil boom in the 1920s. Almost every major oil company began producing crude from the rich field below. Wells sprang up literally overnight, and in less than a month the town grew from 1,500 to 6,000 people. Many of these folks became instantly rich. In fact, many from the East Coast who were given lots of Huntington Beach land years before as part of an encyclopedia sales promotion now found themselves scrambling to find the deeds that would make many of them rich. In addition to the oil production, Huntington Beach also became known for its agricultural strengths. Produce such as lima beans, sugar beets, chili peppers, tomatoes, and celery grew easily in the fertile soil.

From 1957 to 1960, Huntington Beach exploded in size to 25 square miles. In 1956, construction started on the huge Edison power plant along Pacific Coast Highway, and in 1963 the Douglas Aircraft Systems Center opened. This brought major industry to the city, and nearly 8,000 people were employed at the plant.

During the 1960s, Huntington Beach earned the nickname "Surf City" when the popular duo Jan and Dean released the song of the same name. All across the nation, the allure and carefree spirit of the beach lifestyle took root. Huntington Beach still deserves its nickname, as it is home to the International Surfing Museum, the U.S. Open Surfing Championships, and some of the best year-round recreational surfing in the country. The famous Huntington Beach Pier, first built in 1904 and rebuilt in 1914, 1940, 1988, and finally to its current length in 1992, remains the focal point of the city's Main Street district—a symbol of rejuvenated dreams, hope, and determination.

Now more than 100 years old, Huntington Beach remains a Mecca for tourists. It is also home to more than 200,000 residents. Whether a visitor or a local, the views of the city through these postcards are sure to captivate. Postcards typically present a place at its best, so the reader should be prepared to witness Huntington Beach in the most vibrant, industrious, and quixotic light imaginable. The words of some folks who lived this history are abound as well—voices from the past who shed light on what it was like here 80, 90, and 100 years ago.

I am proud to be a resident of Huntington Beach and able to enjoy year-round the kind of lifestyle most people take vacations to enjoy.

Finally, to Marvin Carlberg, thank you for creating this collection over the years. What is a hobby for you has resulted in a significant historical package for the city. For sharing the fruits of your labors with the community, we are in debt. Good job.

—Chris Epting

One

TO BE NEAR THE PIER

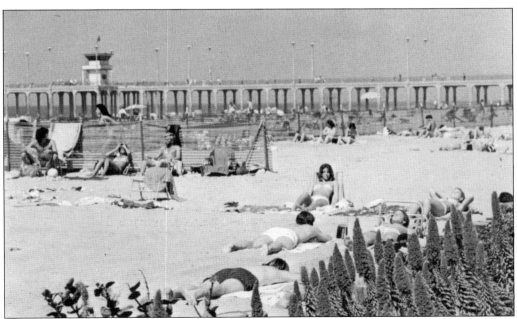

The caption on this 1960s postcard reads, "One of the most popular of bathing beaches in California." The Huntington Beach Pier is visible in the background.

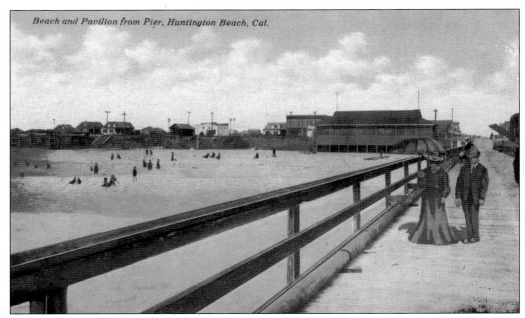

Beach and Pavilion from Pier, Huntington Beach, Cal.

This *c.* 1910 image features the pier in Huntington Beach, which was made of wood, and the Pavilion toward the center. The weather took a severe toll on this original pier, which stood for less than 10 years.

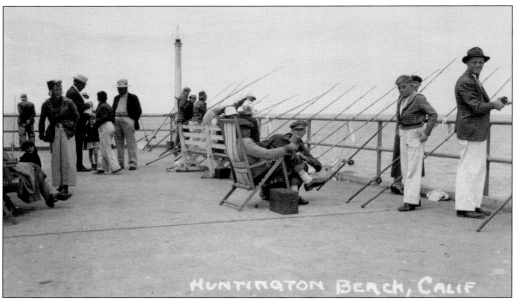

HUNTINGTON BEACH, CALIF

Today, just like it is documented in this 1940s-era postcard, fishing remains a popular activity on the Huntington Beach Pier. (Courtesy of Charles Sanders.)

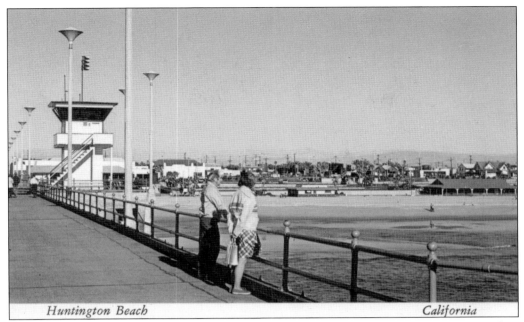

Huntington Beach *California*

This 1970s image taken on the pier features the old Tower Zero lifeguard structure. With binoculars, from this "eye in the sky" lifeguards could see clearly from Newport Beach to Long Beach, allowing them to coordinate rescue operations through radio contact with rescue boats and the individual lifeguard towers on the beach.

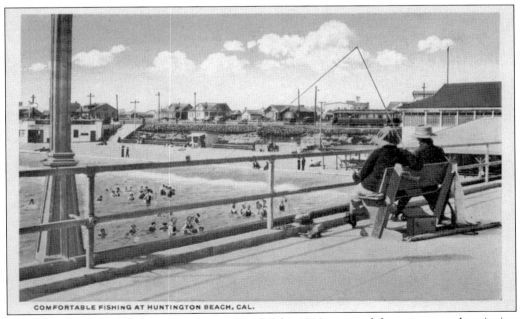

COMFORTABLE FISHING AT HUNTINGTON BEACH, CAL.

Titled "Comfortable Fishing at Huntington Beach," this 1920s postcard shows two people enjoying a day of angling on the pier not far from several bathers. Things took a dramatic turn in the city during this era after oil was discovered in 1920. (Courtesy of Charles Sanders.)

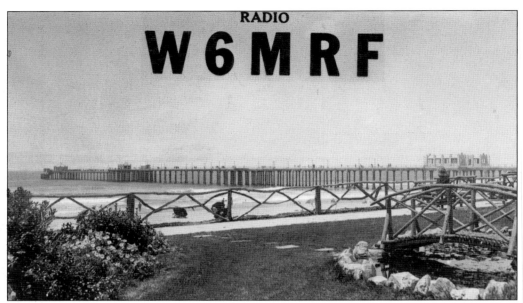

RADIO
W6MRF

This postcard is postmarked May 16, 1938 (5:00 p.m. to be precise). It was sent to Amateur Radio W8LE in Scottville, Michigan. It's a QSL card, which is what amateur radio operators exchanged to confirm two-way communications between stations. QSL means either "do you confirm receipt of my transmission" or "I confirm receipt of your transmission." A QSL card sent from one amateur radio operator to another contained details about the contact and the station (written on the back of the postcard).

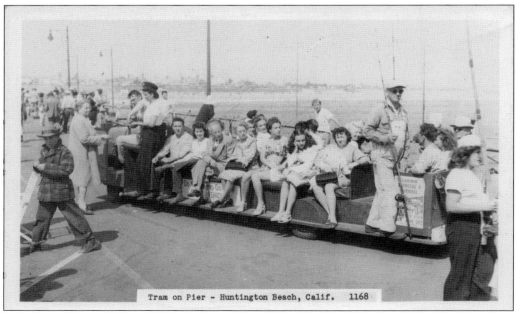

Tram on Pier - Huntington Beach, Calif. 1168

The 1930s tram provided visitors a quick trip out to the pier. Note the ad for the Lions Club Barbecue and Carnival on the side of the vehicle. (Courtesy of Ronn Rathbun.)

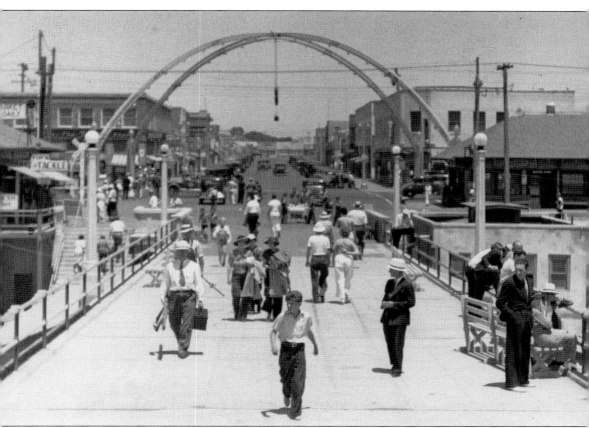

This 1930s image features the famed arch that crossed over the intersection of Pacific Coast Highway and Main Street for several years. It was taken down eventually due to the high maintenance it required, including the salty air that caused it to rust very quickly. (Courtesy of Randy and Sharon Lynn.)

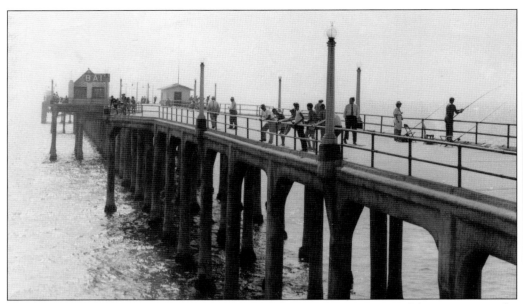

This postcard of folks fishing off the pier is postmarked 1953. A portion of the message on the back reads, "Dear Mom, here we are at the beach. This is the life for me. The weather is perfect. Full moon. We are having a lot of fun."

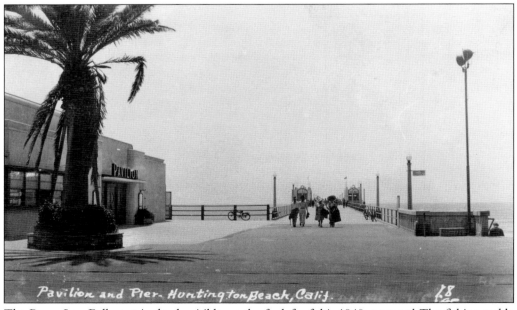

Pavilion and Pier. Huntington Beach, Calif.

The Pav-a-Lon Ballroom is clearly visible on the far left of this 1940s postcard. The fishing tackle shop is in view down the pier on the right on what appears to be a quiet, leisurely day at the Huntington Beach Pier.

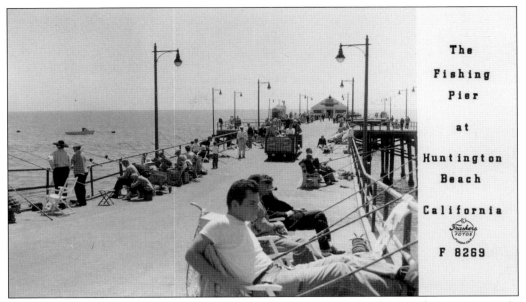

The pier is crowded with fishermen and tourists in this 1949 postcard. Note the tourist tram in the center of the photograph.

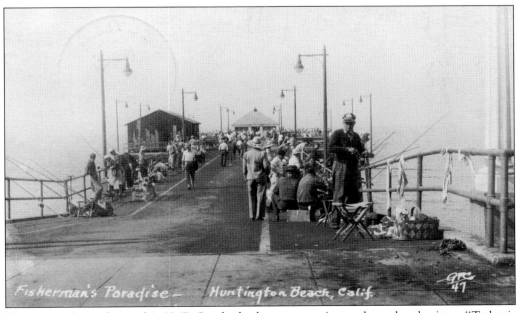

The postmark on this card is 1947. On the back, a message is typed, not handwritten, "Today is perfect (for a change). Now couldn't we just fish and talk? I am going to be fishing pretty soon. Be careful, Mary." It was sent to Greenwood, Mississippi.

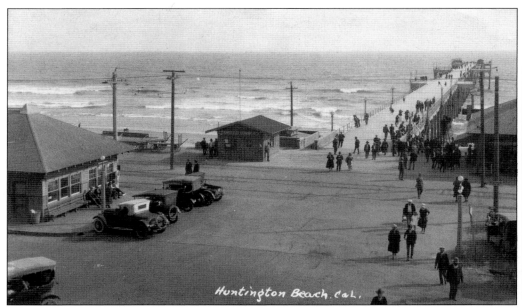

Huntington Beach in 1926 featured the bustle of both the electric railroad and automobiles. Note the pier-side chamber of commerce office in the center of the image. The message on the back of this postcard includes, "There's a high wall here and down by the beach there's a dance hall and amusements. Down on the beach is a building for cooking meals, etc."

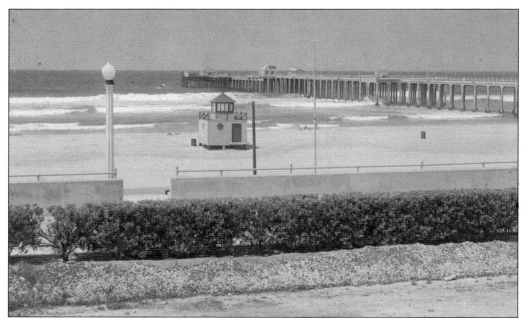

This is a classic 1957 postcard of the Huntington Beach Pier. It was around this time in the 1950s that the now-defunct Meadowlark Airport opened up on Warner Avenue.

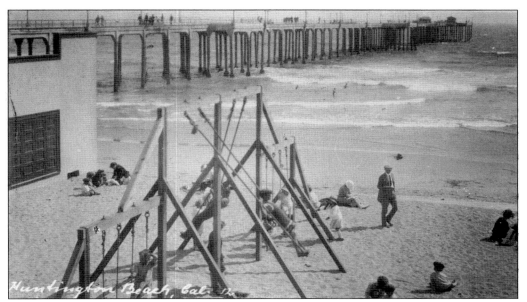

The back of this postcard, postmarked September 13, 1928, reads, "Dear Folks—Arrived here 9th day from S. F. at 10:50 a.m. Some trip!" Back then, there were swing sets on the beach for the kids. Note the gentleman in the full suit and cap to the right of center; going to the beach was a near-formal occasion for some.

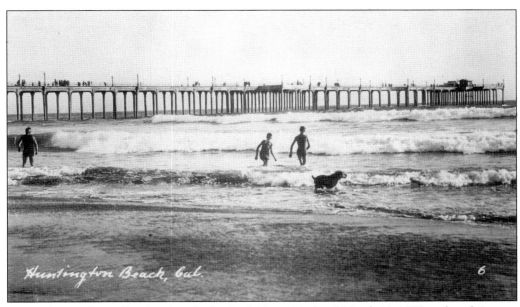

A dog plays in the surf by the pier. The back of this card is dated March 30, 1929, and reads in part, "Dear Mrs. Lingrim: I made a mistake in sending you word that I would go to the city the 3rd of April. A business matter that I always have to look after on the 5th must be attributed to this."

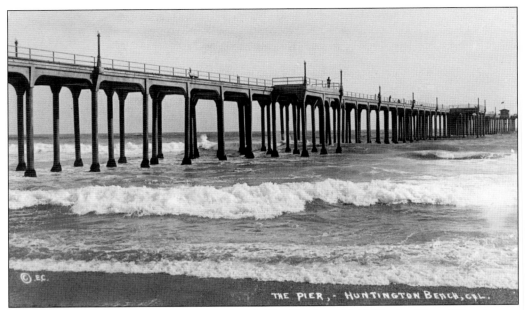

THE PIER, - HUNTINGTON BEACH, CAL.

This is a 1930s image of the Huntington Beach Pier. By the mid–1930s, the City of Huntington Beach had acquired this beach stretching from the pier to Beach Boulevard. Later state beaches were developed on both sides of it, creating some 8.5 miles of nearly unbroken beach.

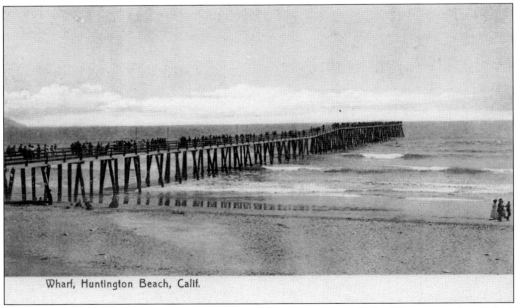

Wharf, Huntington Beach, Calif.

This rare, turn–of–the–century postcard refers to the structure as a "wharf" as opposed to "pier." It is the first pier in Huntington Beach—a 1,000-foot-long timber structure—built in 1904, five years before the City of Huntington Beach was incorporated. In 1912, winter storms nearly destroyed it, and a $70,000 bond issue was approved by the voters to build a new one.

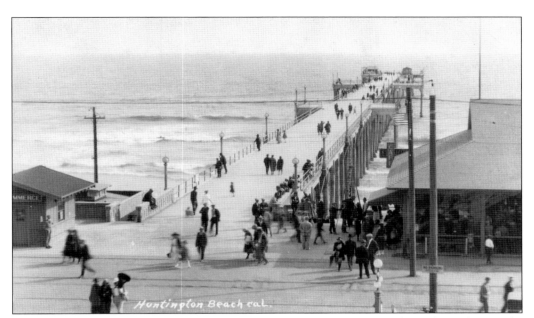

This late-1920s image features the pier in the center and a beachside café on the right. On the back of this postcard, which is addressed to Chicago, a message reads, "Dear Aunt Lois, I'm wishing a happy birthday. Got a cold and I'm in bed. This is one of my postcard collection. Love 4 kisses, Billy Bob."

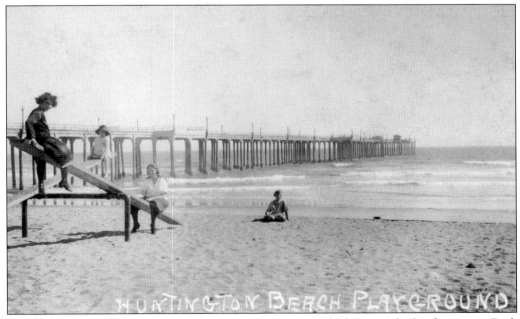

Children pose for this 1920s postcard taken near the pier, which is now built of concrete. Back then, there were playground structures like these seesaws located on the beach to provide a safe and familiar option to play away from the surf.

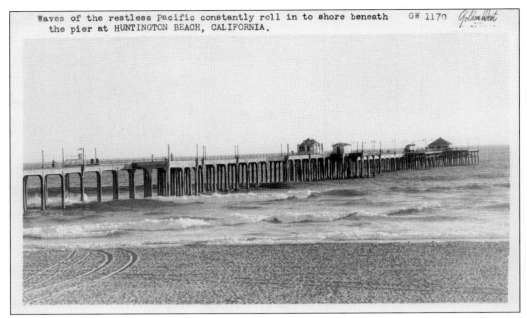

Some poetic language tops this 1940s postcard of the Huntington Beach Pier. It reads, "Waves of the restless Pacific constantly roll in to shore beneath the pier at Huntington Beach, California."

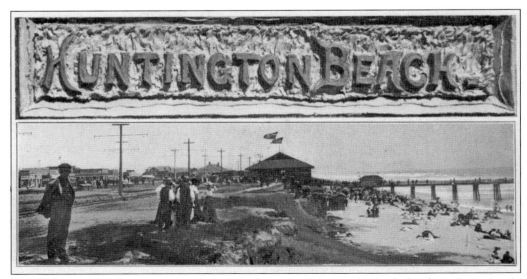

This 1906 postcard features some ornate lettering atop an image that includes the train station in the center and the café on the right.

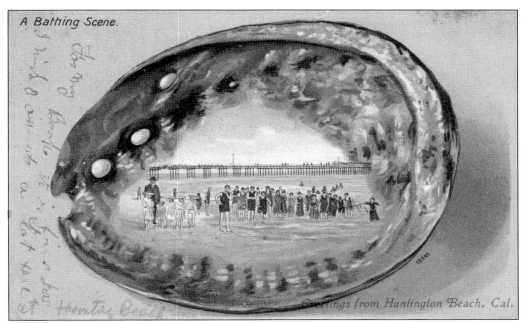

A Bathing Scene.

Greetings from Huntington Beach, Cal.

This is a stunning, artful piece that is postmarked August 10, 1905 (2:00 p.m.). It was sent to Elmer Brown at the Eleanor Ranch. Note that the old wooden "wharf" is featured in the artwork.

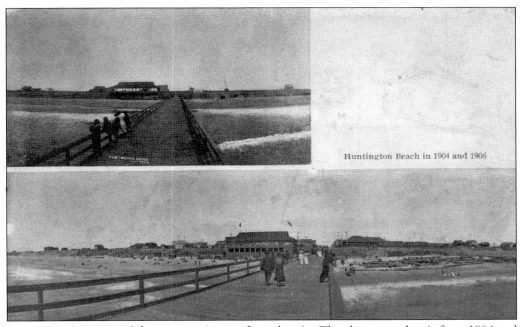

Huntington Beach in 1904 and 1906

As it states, this postcard features two images from the pier. The above snapshot is from 1904 and the photograph below is from 1906. The pier is still made of wood, and no oil wells have popped up yet.

This is a 1912 shot from the pier, the year winter storms would destroy it. Postmarked January 10, it reads in part, "Dear Grandma, Will send you a view of the town in which I am living. You're my best. Regards from Willis, H. B. Calif." It was sent to Pennsylvania.

Seen here is a 1940s-era postcard taken from the pier looking toward Main Street. On the right are the old bleachers that were located on the beach where spectators could watch concerts and other entertainment.

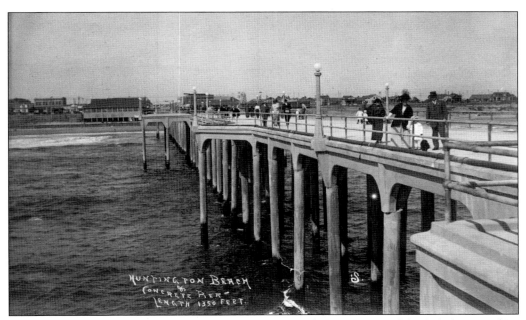

This is an early-1920s postcard taken on the pier. Note the formal dress of the little boy in white in the upper right of the image.

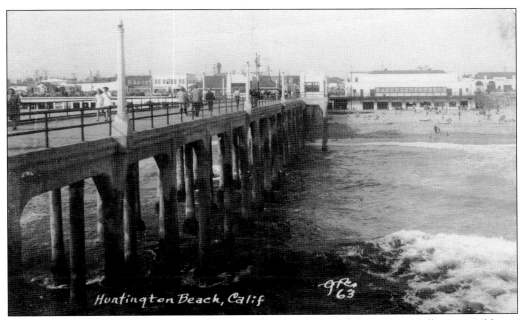

This is another 1940s-era postcard taken from the pier, with the Pav-a-Lon Ballroom visible on the right.

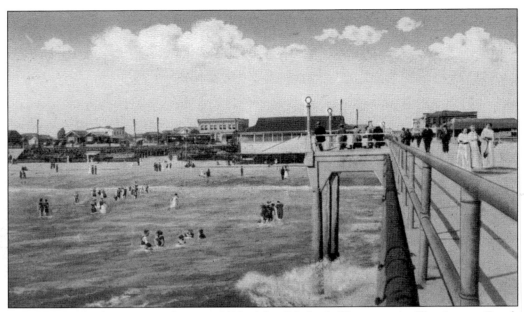

This antique-looking postcard was published by Rigdon's Pharmacy in Huntington Beach around 1915.

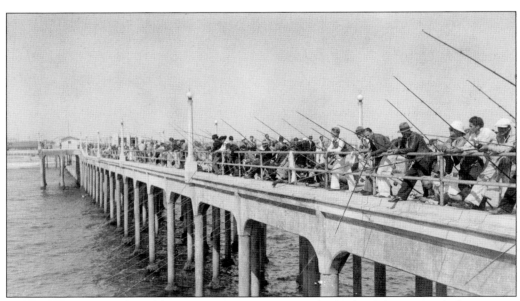

This crowded pier is full of fishermen around 1930. On the back of this postcard, the message reads in part, "Tell Charles we had better come down here to fish. This is at Huntington Beach on the way to San Diego. This is considered to be the largest pier in the world. Could see Catalina Island from here."

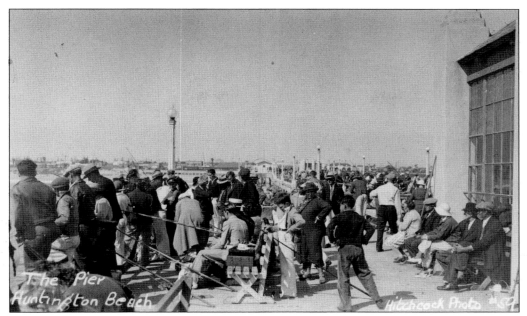

This looks to be another crowded day on the pier in the 1930s. By now, closer to shore, people were starting to bring trailers to park on the grounds, resulting in the creation of the Municipal Trailer Park. The late Alicia M. Wentworth, former city clerk, remembered this era with fondness. "Our trailer, back end of it, was over the sand," she said. "Nine months of heaven for a 20-year-old kid."

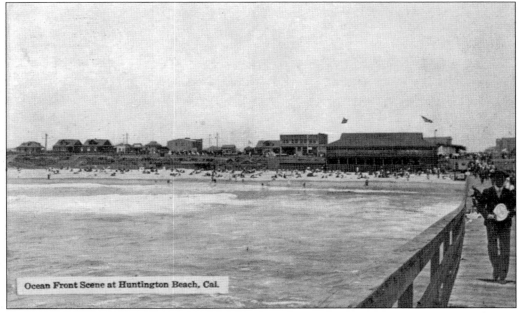

Ocean Front Scene at Huntington Beach, Cal.

The man strolls along the old wooden pier in 1910. This was the year that the city built the famous saltwater plunge at the foot of the pier.

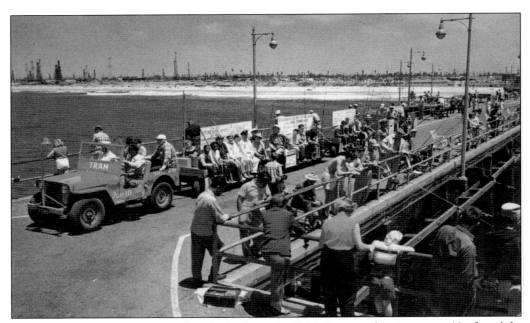

The tram brings visitors out on the pier in the early 1950s. Fares at this time were 10¢ for adults and 5¢ for kids. Note the oil wells off in the distance that are slowly taking over the landscape.

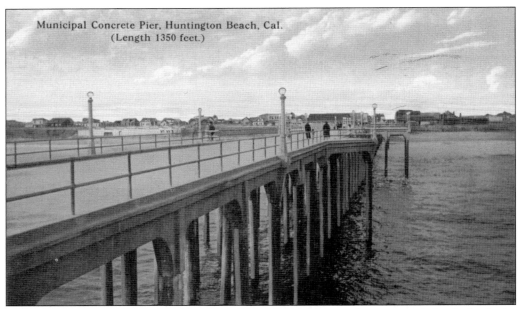

Municipal Concrete Pier, Huntington Beach, Cal.
(Length 1350 feet.)

This c. 1915 image features the concrete pier just a couple of years after it opened. On the back, the following information is printed, "The Industrial City By The Sea. Huntington Beach, in Orange County, California, is located on a high mesa. The city owns a magnificent, solid concrete pleasure pier, 1350 feet in length from which the best of fishing is enjoyed. It is becoming noted as an all year resort as well as an important manufacturing city." The "Industrial" no doubt refers to the Holly Sugar Refinery, the Huntington Beach Broom Factory, and the La Bolsa Tile Factory.

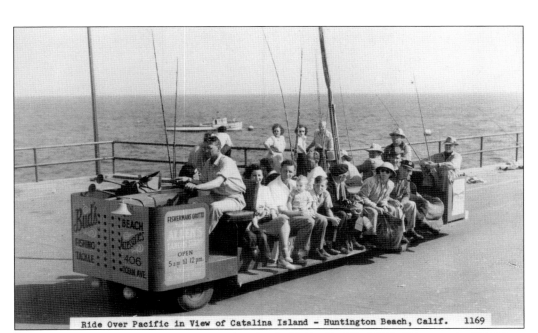

Ride Over Pacific in View of Catalina Island - Huntington Beach, Calif. 1169

This 1940s tram transports visitors across the pier. In 1941, after World War II began, the U.S. Navy moved in and took control of the Huntington Beach Pier, using it as a submarine lookout post. (Courtesy of Ronn Rathbun.)

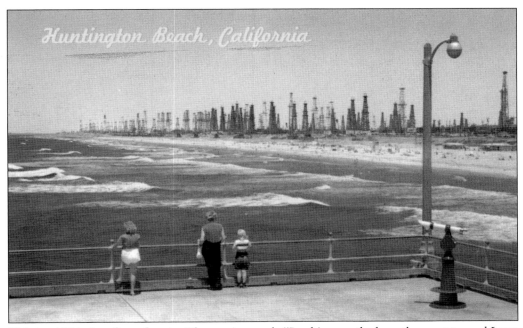

This is a 1956 view from the pier. The caption reads, "Looking north along the coast toward Long Beach. Oil wells in the distance tap a huge offshore pool of oil several thousand feet below the ocean's bed."

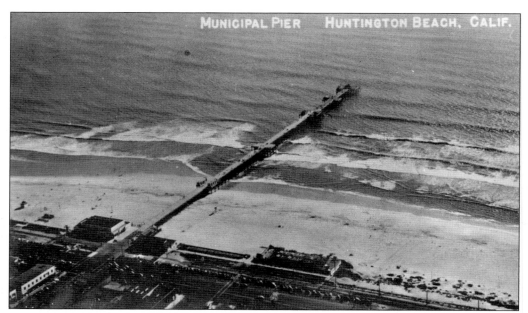

This is an early, rare aerial image of the pier and surrounding area in the 1930s. When this decade began, oil was discovered offshore below the ocean floor. In a successful attempt to preserve the beaches, a technique known as slant drilling was developed to reach the oil from land.

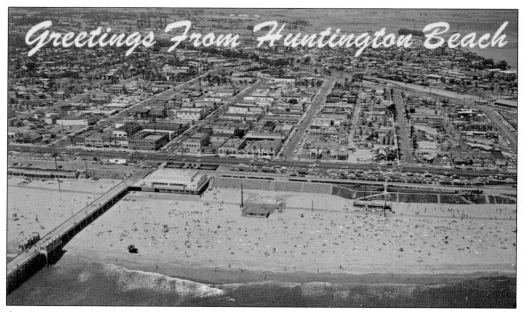

A more recent 1950s aerial shot gives a good perspective of the beach. On the back, the caption reads, "Huntington Beach, California. Spectacular aerial view of one of Southern California's typically beautiful and popular resort and residential communities."

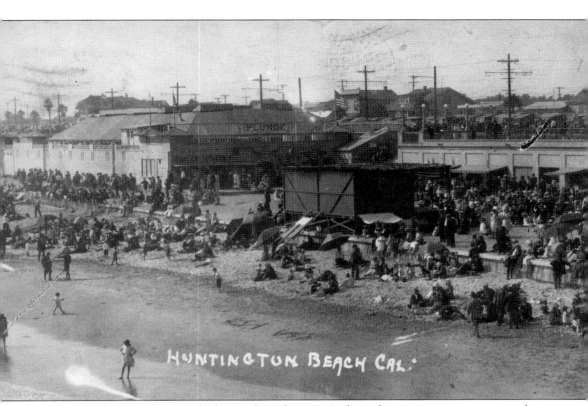

HUNTINGTON BEACH CAL.

The famed saltwater plunge, which piped in therapeutic, heated ocean water, was a popular attraction in Huntington Beach. It is seen here in the center of this 1920s postcard.

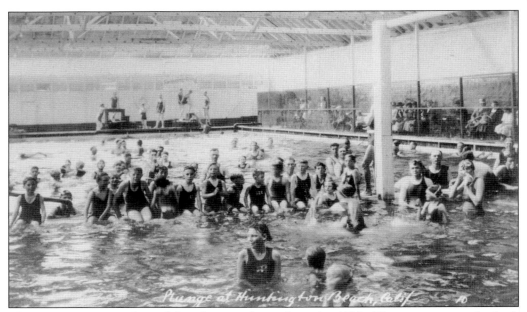

This is a rare interior shot of the saltwater plunge from the 1920s. Plunges were popular back then, and in Redondo Beach, Henry Huntington built one in 1909 that was known as the "largest indoor salt-water-heated pool in the world."

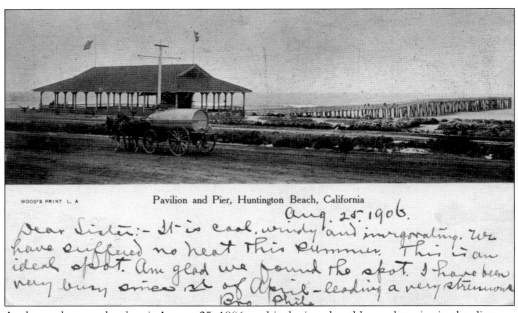

As the card states, the date is August 25, 1906, and it depicts the old wooden pier in the distance and the original Pavilion in the foreground. Below the image, it reads, "Dear sister, it is cool, windy and invigorating. We have suffered no heat this summer. This is an ideal spot. Am glad we found the spot. I have been very busy since 12th of April—leading a very strenuous." It stops there and is signed, "Bro. Phil." One can't help but wonder what the rest of Phil's thought was.

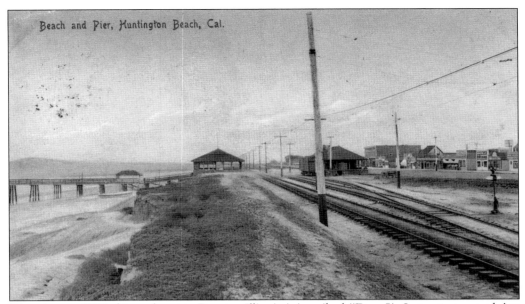

Beach and Pier, Huntington Beach, Cal.

From August 1908, this card sent to Decatur, Illinois, is inscribed, "Dear Sis: Just got your card. Am glad you like the picture. Tell Ralph hello for me + to behave himself or I'll have to punish him severely. We're down here at Huntington Beach for a mo. And are just having a dandy time. Write soon. With love, Sis." The train tracks for the Red Car Line are clearly seen on the right.

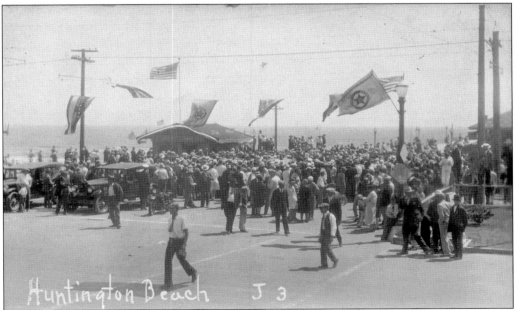

Huntington Beach J 3

This may be one of the city's early Fourth of July events as throngs gather near the pier in the mid-1920s. The Fourth of July celebration is the city's oldest community tradition. It first began in Huntington Beach in 1904 to commemorate the arrival of the first electric passenger train, linking the still unincorporated area with Long Beach and Los Angeles. The board of trade, a business association and forerunner of the chamber of commerce, sponsored this initial event that boasted a crowd of 50,000, many of whom were enticed here by the sales pitches of real estate promoters.

31

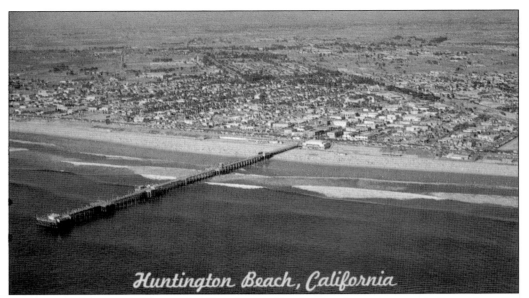

Huntington Beach, California

A 1968 aerial postcard features the Huntington Beach Pier. Just two years before this, a fire destroyed a large portion of the Pavilion near the pier. The famed structure had hosted many of the city's major events, including the famous Twin Convention. Just before Labor Day weekend, sets of twins would arrive from all over California to compete in various contests. It began in 1935 and ran through the 1950s. After the structure was rebuilt, the Pavilion was turned into the Fisherman restaurant; a few years later, it was renamed Maxwell's.

Huntington Beach, California Entrance to the Pier

This is a more modern, c. 1975 postcard of the area around the pier. By then, the Fisherman restaurant was located where Duke's is today.

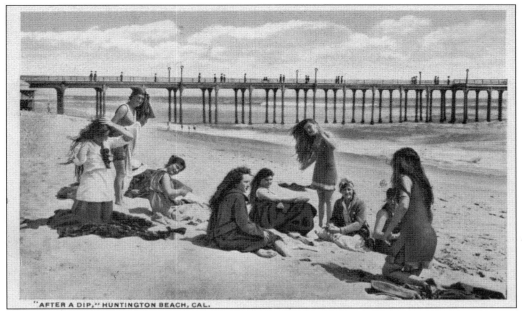

"AFTER A DIP," HUNTINGTON BEACH, CAL.

"After a Dip" is the caption on this postcard, which is postmarked August 19, 1920. Sent to Pasadena, it reads, "My dear Josie! Here I am way down here with a friend of mine, Have been here all week. Will return to Pasadena Sunday if nothing happens. Am having a fine time. Wonder where you are. Will be glad to see you Monday. Much love to Jane and your mother—also lots to you. Lovingly yours, Gertrude."

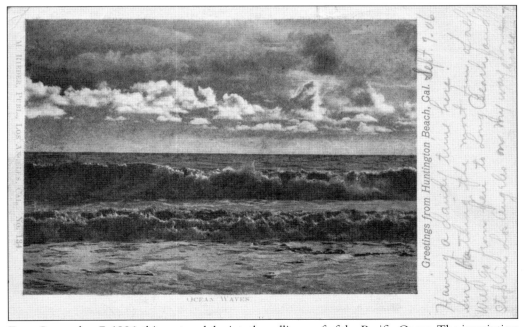

OCEAN WAVES

From September 7, 1906, this postcard depicts the rolling surf of the Pacific Ocean. The inscription reads, "Having a dandy time here! Surf bathing the most fun of all. We go from here to Long Beach and stop in Los Angeles on the way. Having a ball."

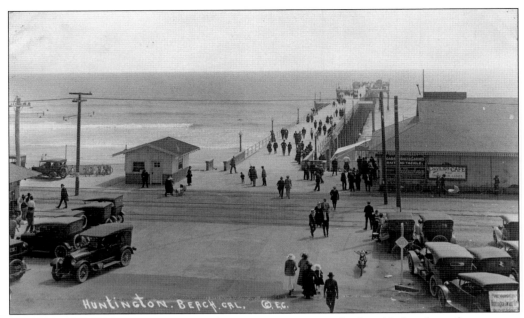

This is yet another 1920s image near the pier. Note once again the old chamber of commerce building on the left and the railroad tracks running through the center of what is now Pacific Coast Highway.

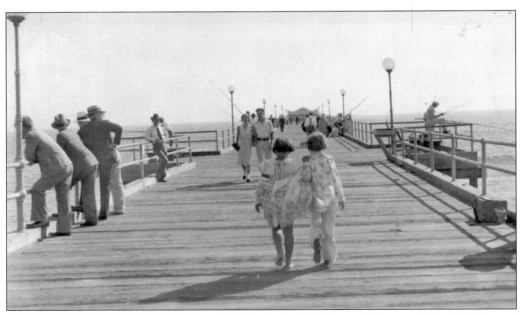

A 1939 snapshot of the pier depicts two little girls on a stroll among the fishermen and admirers of the Pacific. Though it has been rebuilt in concrete, the walkway is still made of wooden planks.

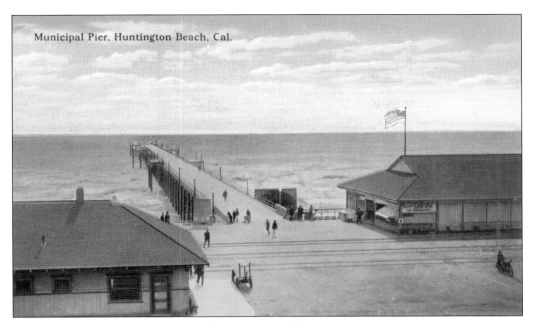

Municipal Pier, Huntington Beach, Cal.

Originally printed in color, this beautifully painted *c.* 1920 postcard features the new concrete pier, the café to the right, and the train station to the left.

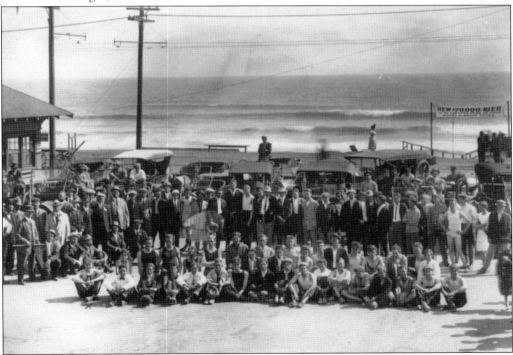

This is a 1913 group portrait of the participants and audience of the Annual Orange County-Riverside County Relay Race. Morris Martenet Jr., sitting on the far left of the first row with the "x" marked below him, was the winner. The sign in the right background confirms that this photograph was taken at Huntington Beach before the new $70,000 pier was built.

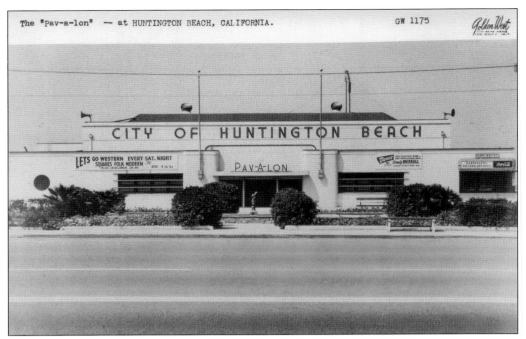

The Pav-a-Lon Ballroom, located next to the pier, was a popular dance hall for many years. Many favorite bandleaders, like Hoagy Carmichael, performed here in the 1930s and 1940s. In this particular 1940s postcard, a night of square dancing is being advertised. (Courtesy of Aaron Jacobs.)

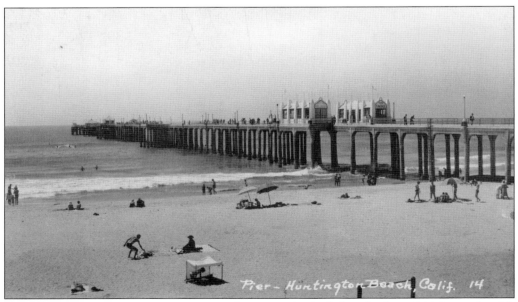

A quiet day at Huntington Beach is seen in this postcard, which dates back to 1945. Soon after this shot was taken, in June 1946, the city installed the first parking meters on Main Street and Pacific Coast Highway. The toll was 5¢.

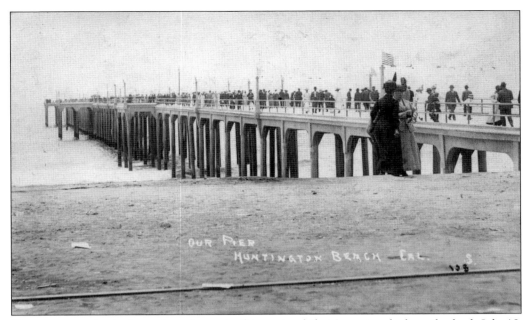

The concrete pier is almost brand new in this postcard that is postmarked on the back July 12, 1914. It was mailed to Baxter Springs, Kansas, with a note that begins, "Dear Bertha, It has been a time since I wrote you but I think of you often. How do you like the looks of this pier? This would be a great place for you."

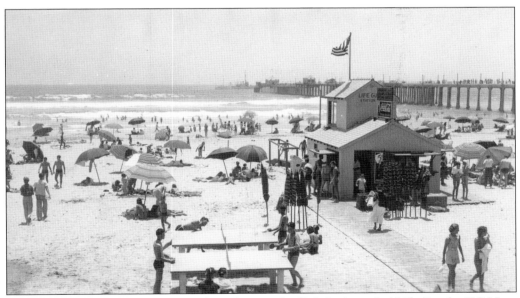

This postcard shows Huntington Beach on the Fourth of July in the early 1940s. See the U.S. Navy ship off in the distance? Locals and tourists could be shuttled out there to see what life was like on a service ship during the war. Notice also the ping-pong tables on the sand where today there are volleyball courts.

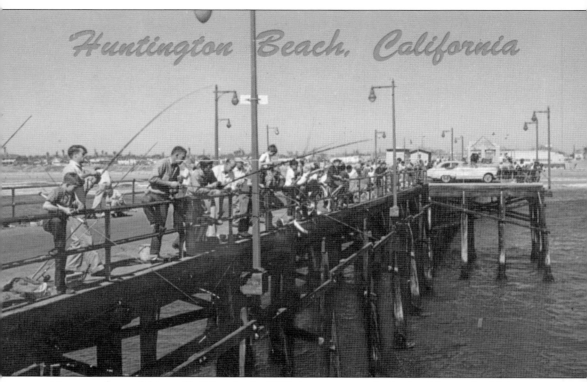

Here people are fishing off of the pier in 1970. A message on the back of the card, which was sent to Wisconsin, reads, "Arrived safe. Weather is nice and warm. Had a nice trip."

Two

Open Spaces, Growing Places

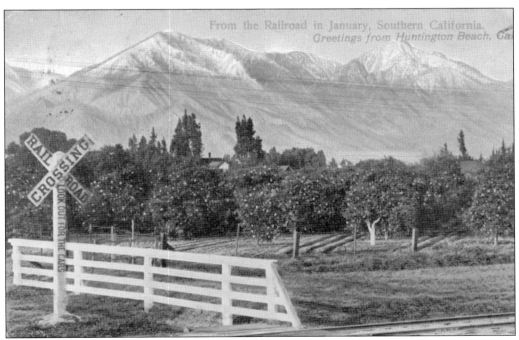

Here is a postcard of an orange grove in Huntington Beach. The San Bernardino Mountains seem to be artistically exaggerated in the background. (Courtesy of Charles Sanders.)

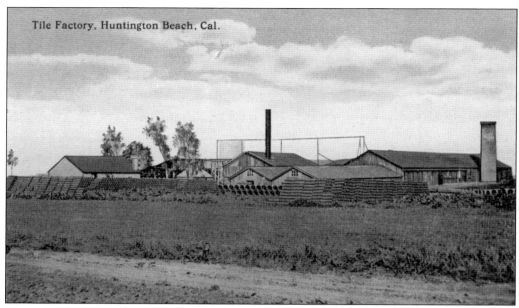

Tile Factory, Huntington Beach, Cal.

Pictured is La Bolsa Tile Company, located at Gothard and Ellis Streets, around 1910. Along with the Holly Sugar Refinery and the Huntington Beach Broom Factory, the La Bolsa Tile Factory was one of the primary employers in town until the discovery of oil.

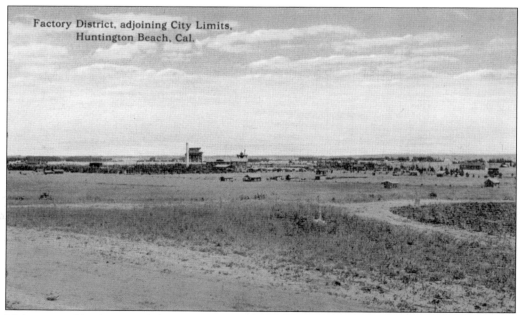

Factory District, adjoining City Limits, Huntington Beach, Cal.

This postcard looks toward the old Holly Sugar Plant near Garfield Avenue and Gothard Street around 1911. It was built in 1910, when Orange County contained more than 30,000 acres of sugar beets. The plant cost $1.25 million to construct and would remain Huntington Beach's primary industry until oil was discovered in 1920.

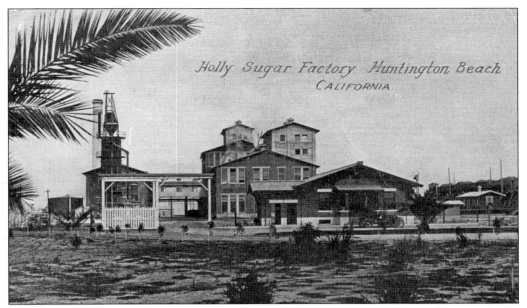

This is another postcard of the Holy Sugar Plant, postmarked July 24, 1912. Part of the inscription reads, "I got here in time for dinner yesterday. Baby is weak—but doing nicely. They can change her diet today—give her egg and rice. Has had nothing but malted milk."

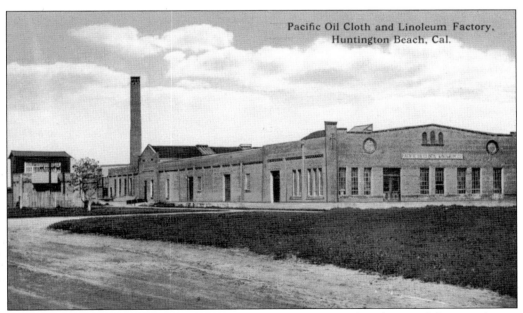

The Pacific Oil Cloth and Linoleum Factory is seen in this postcard. Built around the same time as the broom factory, the sugar plant, and the tile factory, this company employed close to 250 people in Huntington Beach and cost $200,000 to build.

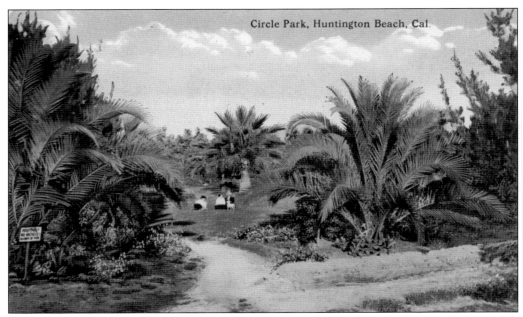

This is Circle Park around 1915. Today it is called Farquhar Park, located on Main Street just across from Lake Park at Twelfth Street. Farquhar Park was once called Circle Park because it was surrounded by streets, giving it a circular shape. In 1967, Circle Park was combined with an adjacent parcel, creating one large park. Farquhar Park is named after one of Huntington Beach's well-remembered citizens, James S. Farquhar. Farquhar was the publisher of the *Huntington Beach News* for 43 years and an exemplary citizen as well.

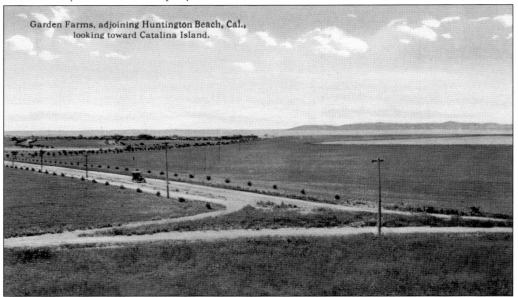

A 1915 postcard states, "Garden Farms, adjoining Huntington Beach, Cal., looking toward Catalina Island." An early official logo for Huntington Beach actually features a view of the island, which is about 25 miles offshore. This view is adjacent to what is now the Bolsa Chica wetlands area, but back in about 1912 there were open fields here where flowers were harvested.

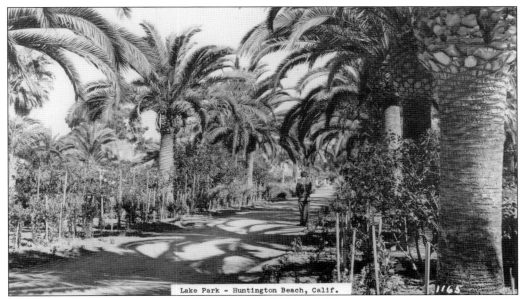

This is a shot of Lake Park in the 1930s. Today Lake Park is the location of Huntington Beach's historic Boy Scout Cabin, as well as a popular place to take the kids, dogs, and anything else that needs a peaceful place to play. Lake Park was the second park developed in Huntington Beach. The land was purchased in 1912 and was named Lake Park because of the small fly-fishing lake, which is now filled in with a playground for children.

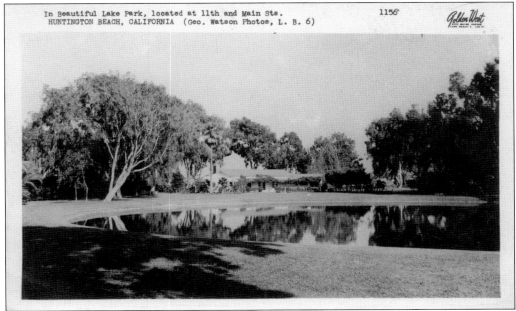

A 1950s postcard of Lake Park documents it when there still was a lake. (Courtesy of Randy and Sharon Lynn.)

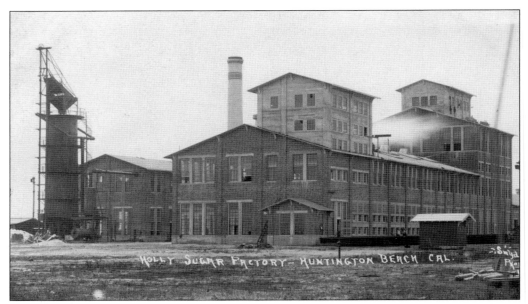

Pictured is the Holly Sugar Factory around 1915. The area's fertile ground that yielded sugar beets attracted the Holly Sugar Company of Colorado. The plant was completely electric and state of the art for its day. It processed the beets and turned them into refined sugar. The plant was one of the city's largest employers.

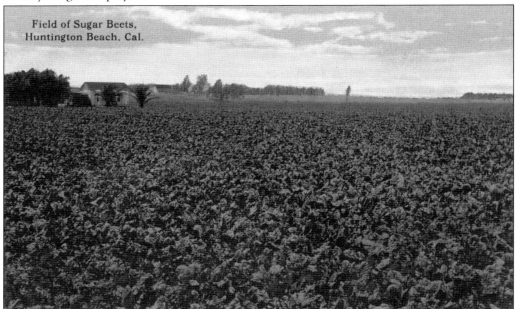

This image depicts a "Field of Sugar Beets" around 1914. Part of the Industrial City by the Sea series, the information on the back of this postcard reads, "One of the largest sugar factories in the world is located here, one of five in Orange County, where over $6,000,000 worth of sugar was made in 1914. The back country immediately tributary, includes the famous peat land district, the richest soil on earth. Write to Chamber of Commerce for full particulars." The language is as charming as the image.

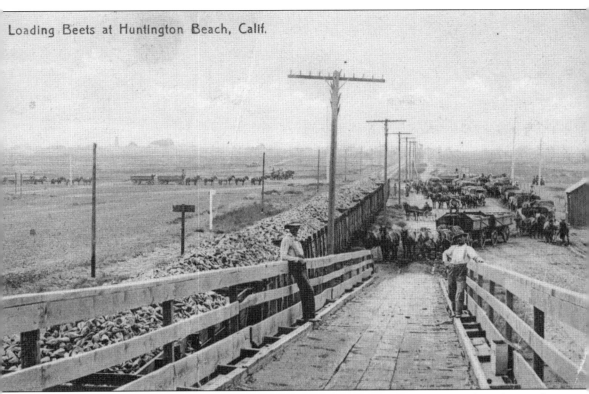

Loading Beets at Huntington Beach, Calif.

"Loading Beets at Huntington Beach, Calif." is seen on the front of this 1916 postcard. Evidence of how big this industry was is fully apparent in the image. Beets were a very labor-intensive crop to cultivate, and many immigrants worked here, helping form the backbone of this and several other Orange County industries. Introduction of the railway through the center of Huntington Beach allowed the beets and other products to be shipped throughout the state and beyond, further solidifying the city's reputation of being an agricultural centerpiece before the discovery of oil just a few years later.

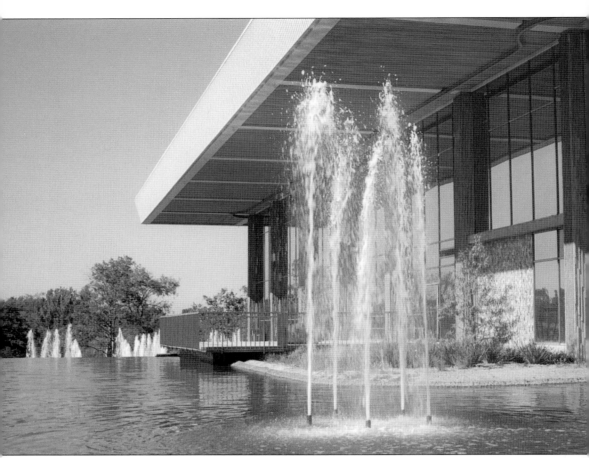

The Huntington Central Library is nestled among trees and lakes in the middle of 350-acre Central Park. Architect Dion Neutra stated his goal was to allow the park "to penetrate and flow through the new library structure with the greatest possible contact with nature." This was successfully accomplished in part via floor-to-ceiling windows with lovely views near and far, atriums, and indoor water features. In front of the new library in 1975 was a Literature Heritage Garden with hundreds of plant varieties chosen because of their importance in literature, such as being mentioned by Shakespeare, in the Bible, or included in other writings. The coauthor's mother (Margaret Carlberg) helped establish and maintain this garden until around 1992 when the land was needed during construction of the library's children's wing expansion. (Photography by Jim Reed. Postcard courtesy of the Huntington Beach Central Library Gift Shop.)

Three

MINDING THE BUSINESSES

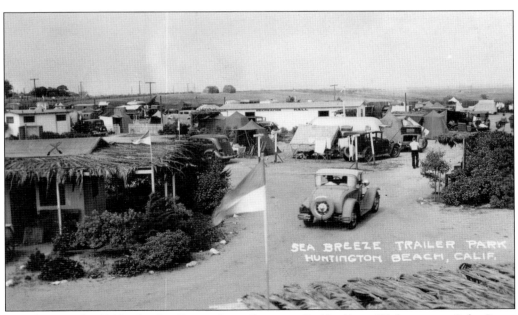

Seen here in the 1930s, the Sea Breeze Auto Court on Pacific Coast Highway near Lake Street was a popular camping spot for many years. It opened around 1929, and later it became the Sea Breeze Trailer Park.

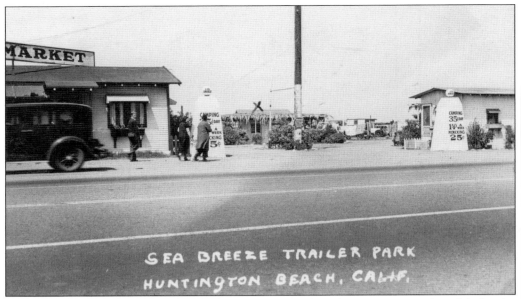

This is another angle of the Sea Breeze Auto Court. Look at those prices; camping right by the beach for 35¢ per day and just $1.50 per week.

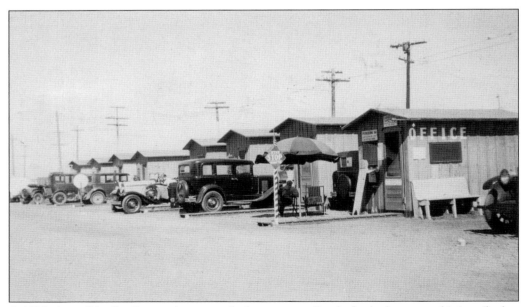

A 1930 view of the Sea Breeze shows a packed auto court. On the back, the postcard is inscribed to someone in Altadena, California, "Holding cabin for you for Aug. 23. Everything is okay." As well, there is a slogan that reads, "Sea Breeze Auto Camp—The Best Camp in the West for the Money."

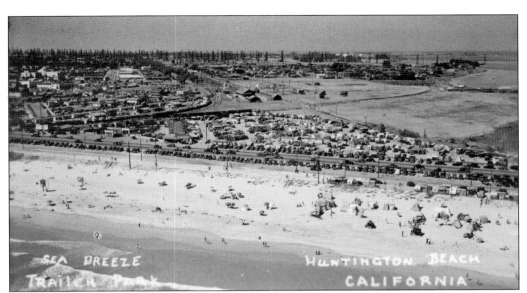

This incredible 1930s aerial gives the reader an idea of how vast the Sea Breeze Auto Court property was. In the distance, there is evidence of the oil boom that started the decade before.

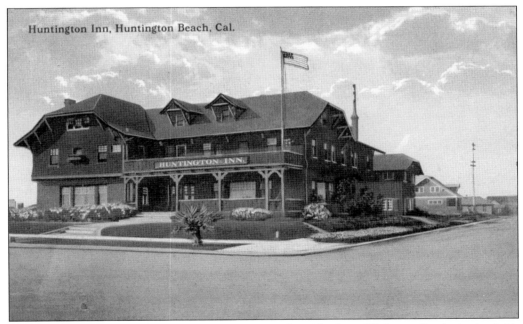

The Huntington Inn was located at Eighth Street and Pacific Coast Highway. On the back of this postcard, postmarked July 30, 1915, Ben writes to Miss Erma Wims, "Dear Friend, how are you? I go swimming every day in the ocean at about 3 p.m. I am so sunburnt that I can hardly write. My face has begun to peel off already. This is a picture of where I am staying."

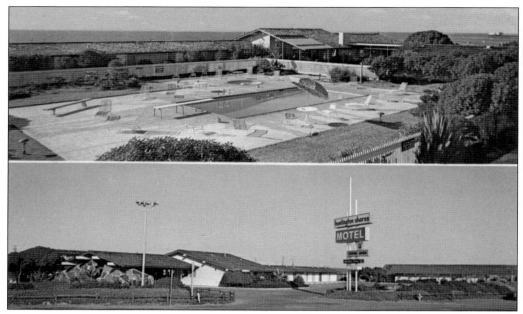

The popular Huntington Shores Motel was located on Pacific Coast Highway from the 1960s until it was razed to make way for newer resort hotels in the early years of the 21st century. Located right next door was the locally popular Grinder restaurant.

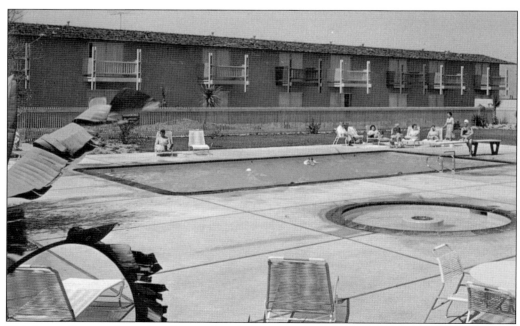

This image features the swimming pool at the Huntington Shores Motel. This is where many of the bands who played at the Golden Bear night club would stay when they were in town.

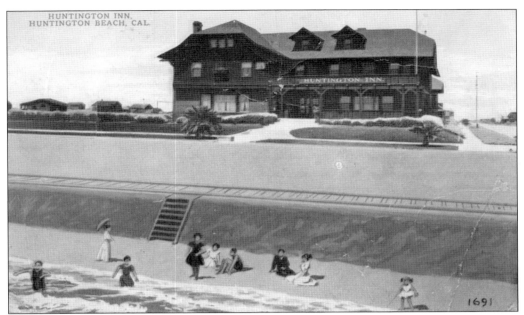

This promotional postcard of the Huntington Inn was mailed in 1912 with a preprinted message on the back, "The classiest and most home-like hotel on the South Coast. Located on a 35-ft. bluff overlooking the Pacific, and surrounded by the famous peat land celery fields of Southern California."

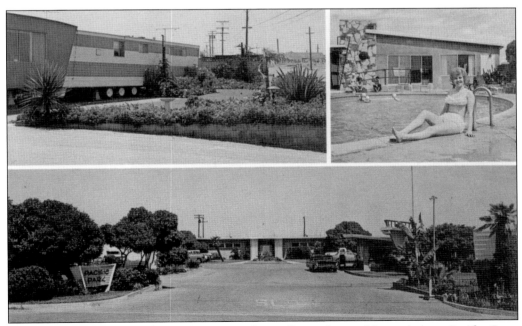

Pacific Park, seen here in the 1960s, was another trailer park motel located along Pacific Coast Highway. (Courtesy of Randy and Sharon Lynn.)

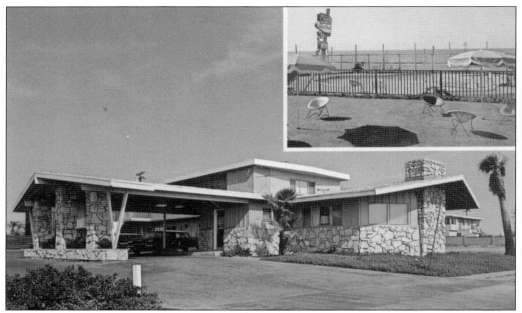

The Sun'n Sands Motel has been a fixture in Huntington Beach since the mid–1950s. In an era when the city is starting to be dominated by resorts and upscale tourist hotels, the Sun'n Sands still offers bargain prices in a fun, 1950s sort of setting right on coast highway and is a stone's throw from the ocean. This postcard is from the 1960s.

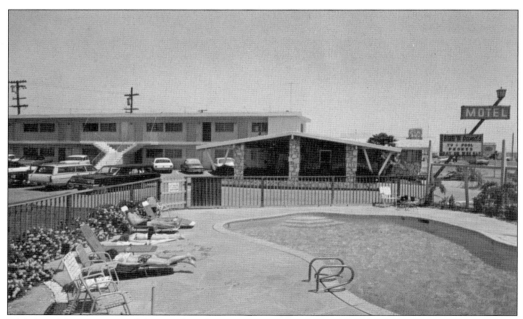

This is a 1960s image of the pool at the Sun'n Sands Motel. Today it has been filled in as part of the front parking lot.

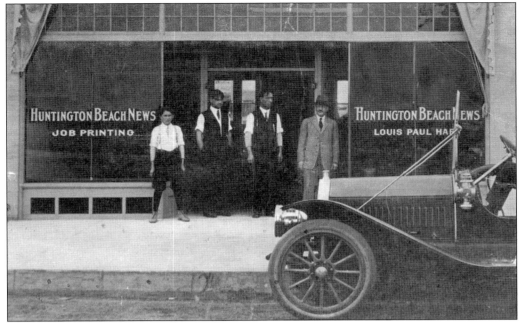

An early 1920s postcard captures the venerable *Huntington Beach News*, which operated on Main Street for many years. Today at the Central Library in Huntington Beach, it is possible to read through copies of the old paper on microfilm.

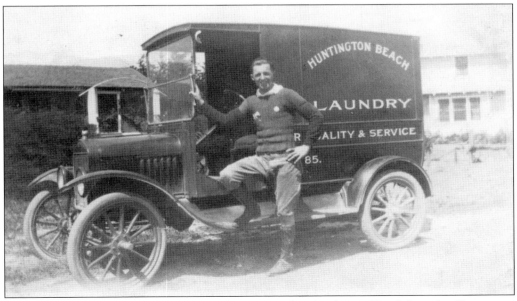

This early 1920s postcard was created to help promote the Huntington Beach Laundry Company.

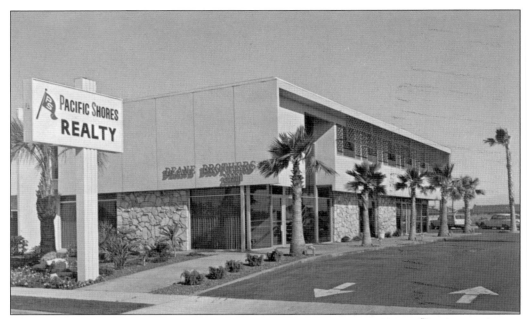

The Pacific Shores Realty Company, seen here in the 1960s at Beach Boulevard, is no longer located there, but the building still stands.

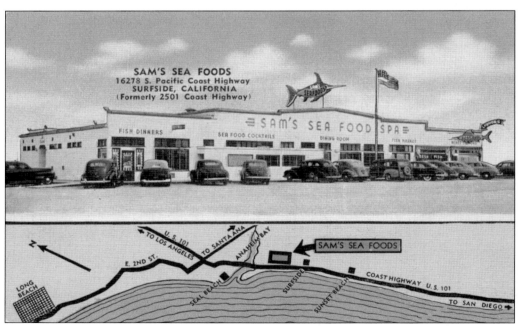

According to local historian Chris Jepsen, "Ever since it began as a small fish market in the 1920s, Sam's has been called Sam's. It was once called Sam's Sea Food Spa and later it became Sam's Seafood Restaurant and Hawaiian Village and eventually just Sam's Seafood. But the name always paid tribute to the founder of the business, Greek immigrant Samuel Arvenites." Here it is pictured in the 1930s. Today the building is there, but the restaurant has been renamed Kona.

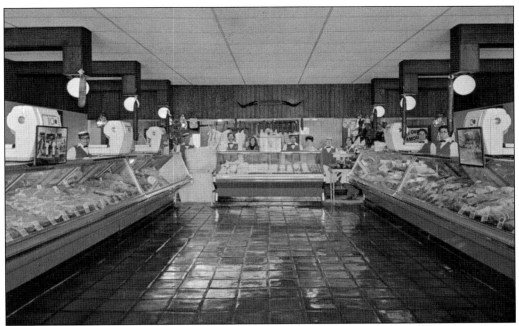

Talk about a carnivore's dream. Step into the Beef Palace butcher shop on Warner Avenue near Springdale Street and it feels like home. Wall-to-wall glass cases display the highest-quality, most mouthwatering meats around, with a friendly and helpful staff ready to assist with selection, grilling tips, or special trimming requests. This 1970 advertising postcard shows the store's walls oddly barren—today they are filled with cowboy Americana, kitschy posters, and newspaper articles raving about one of Orange County's last true full-service butcher shops.

This is a 1960s image of the Sheraton Beach Inn on Pacific Coast Highway, which today is the site of the Hyatt Resort.

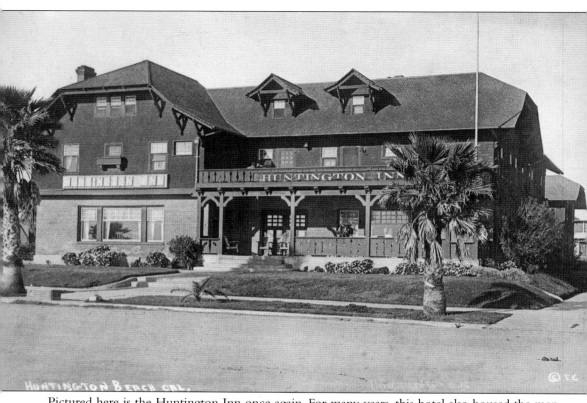

Pictured here is the Huntington Inn once again. For many years, this hotel also housed the men who came to work in the oil fields. Later the Elks Club used the facility as a meeting place. The building was knocked down in 1969, and a Quality Inn now exists at the site.

Four

THEY CAME RUSHING
TOWARD THE GUSHING

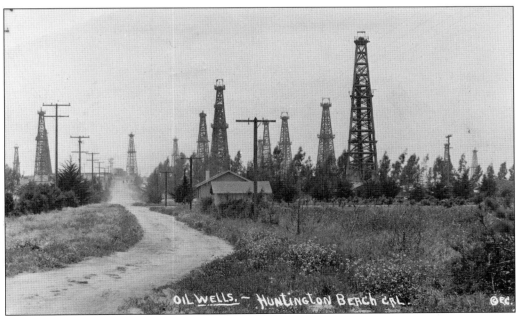

This postcard features the oil wells at Clay and Goldenwest Streets in the mid-1920s. During this time, despite the attention oil wells brought to Huntington Beach, the city and surrounding area still remained a vital agricultural-producing zone. The mineral-rich, fertile land was used for growing beans, tomatoes, celery, and several other cash crops. (Courtesy of Aaron Jacobs.)

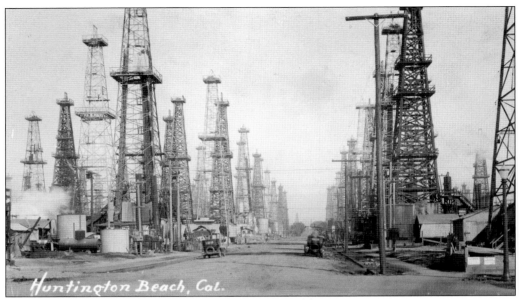

The oil boom has definitely hit in this *c.* 1925 postcard. It was hard to find a house to rent around this time due to the boom, which caused some workers to live in tents. (Courtesy of Charles Sanders.)

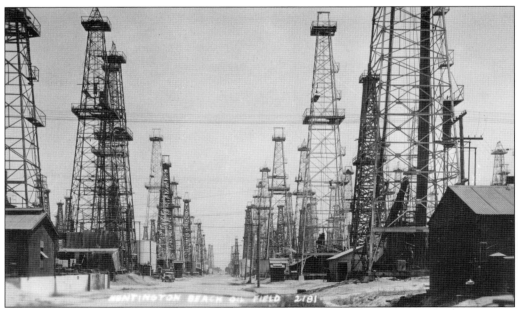

In 1919, representatives of the Huntington Beach Company met with Standard Oil and leased 500 acres to Standard for exploratory drilling. Soon after, Standard's Bolsa Chica No. 1 became the Huntington Beach Discovery Well. It came in as a gusher, producing 2,000 barrels per day, and development of six areas and five major booms soon followed. This made Huntington Beach California's fourth-largest oil field. (Courtesy of Charles Sanders.)

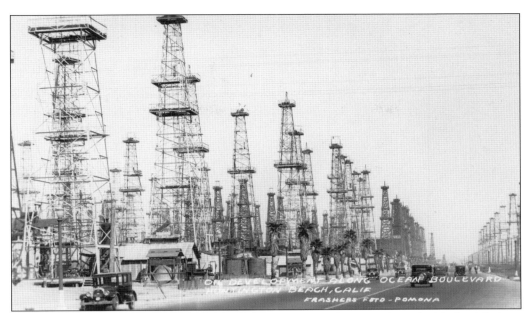

Ocean Boulevard, which eventually became Pacific Coast Highway, is adorned with derricks here in the 1930s. The initial Huntington Beach oil boom, located in the Golden West-Garfield area, lasted from 1920 to 1923. From 1922 through 1926, the low-yield Barley Field area was developed. (Courtesy of Charles Sanders.)

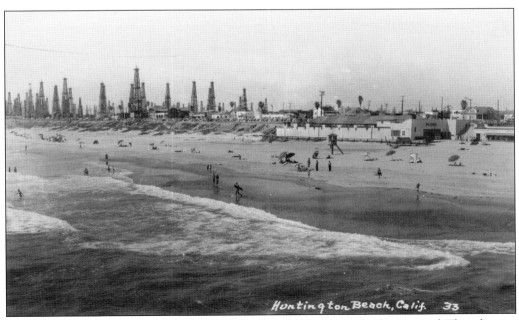

The pier had a great view of the oil fields in the late 1930s, as seen in this postcard. The saltwater plunge is visible in the middle right of the image. (Courtesy of Charles Sanders.)

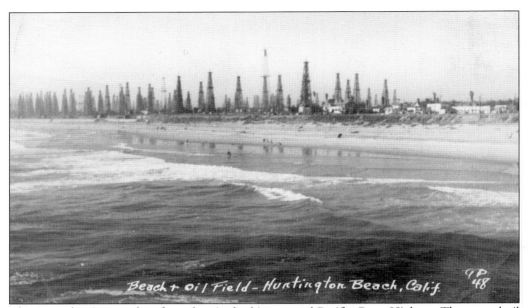

This is another image taken from the pier looking toward Pacific Coast Highway. The second oil boom in the city began when the lower or main zone of the Seventeenth Street Townlot area was tapped in 1926. On the Pacific Coast Highway, Wilshire Oil drilled Huntington Beach No. 15, producing 4,800 barrels per day.

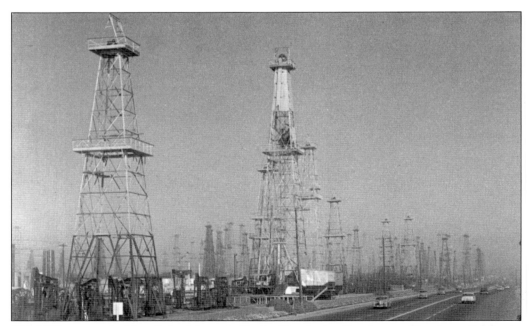

This 1950s postcard of the oil derricks reads, "In the Huntington Beach area of Southern California, rows of closely spaced oil well pumps bob up and down in erratic rhythm, lifting oil from a great tideland pool beneath the ocean's floor."

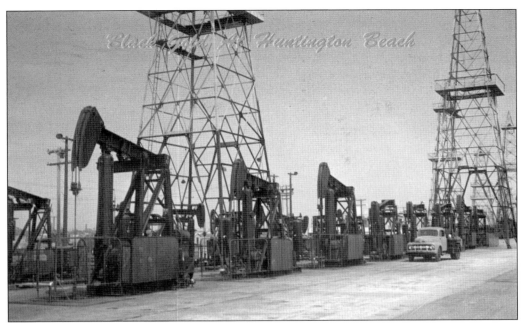

There is an interesting inscription on the back of this postcard, postmarked July 30, 1966, that was sent back to New Jersey. It reads, "Hi, Spending a few weeks out here, wonderful weather. Playing a little golf. Got mixed up in these oil wells. Bill"

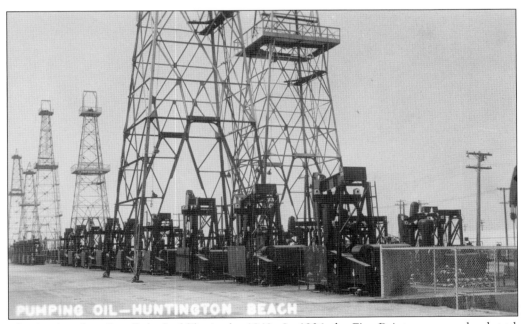

This is what the oil wells looked like in the 1940s. In 1936, the Five Points area was developed. This was followed by a resurgence of activity in 1943 and the drilling of Mize No. 1 in the Townlot Tar Zone that triggered the fourth boom. A dozen years later, the last oil boom took place with the development of the Southeast Townlot Extension.

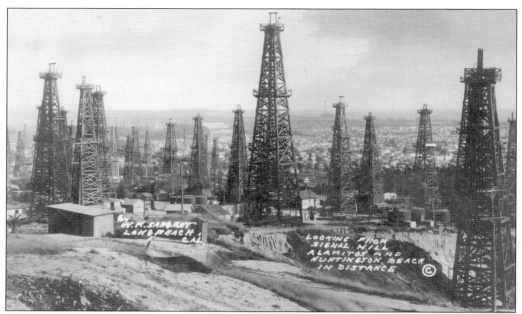

Of course, Huntington Beach wasn't the only city in Southern California to strike oil. This image, looking toward Huntington Beach, comes from the top of nearby Signal Hill around 1925.

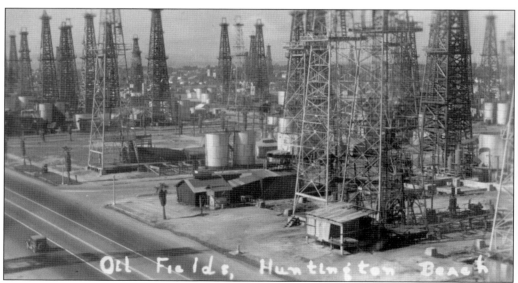

This August 27, 1942, image takes a closer look at the derricks. On the back of this postcard, sent to Augusta, Kansas, Dora Jiggs writes, "Dear Mrs. Cott: These oil wells are first as you come into H. B. They are really a sight to see. We are still having a wonderful time and still like it swell. How is everyone at home? Will write a letter today—please keep this card for us."

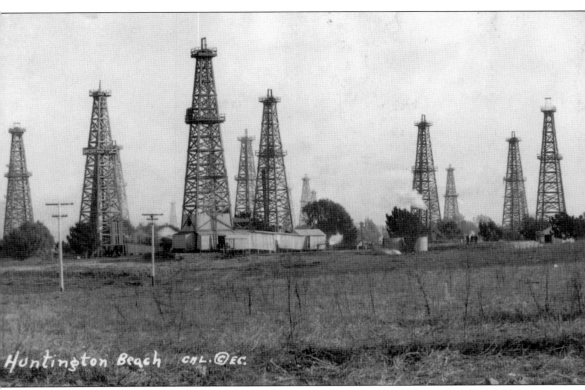

Huntington Beach CAL. ©EC.

The oil boom was still in its infancy when this postcard, postmarked November 6, 1922, was written. Right around this time, a national ad campaign brought in thousands of new people hoping to get rich from oil.

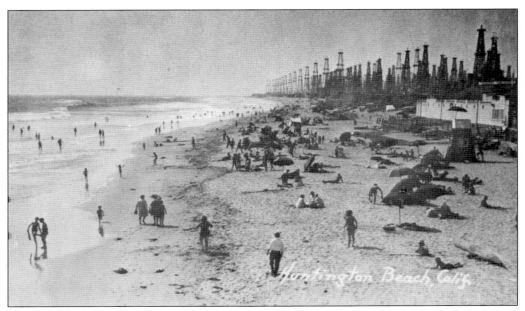

Here the beach and the oil fields are almost intertwined from a pier view in the 1930s. Imagine the noise, not to mention the smell, of pumping oil wells this close to shore.

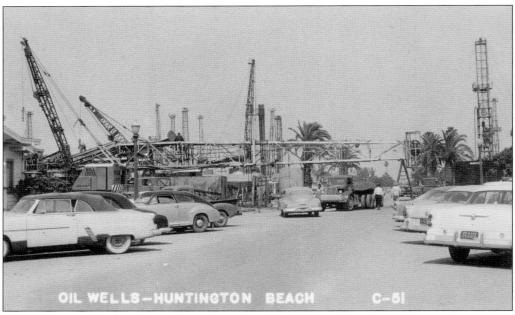

This is a view near Goldenwest Street in the late 1940s. In 1948, the state moved in and bought 11,000 feet of beach property stretching from the Municipal Trailer Park to the Santa Ana River. This new state beach became the foundation for Huntington Beach State Park.

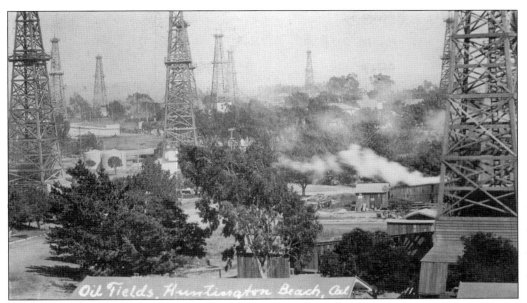

A 1927 postcard depicts the massive effect and impact oil wells had on the scenery. Along with the oil wells came many 10-foot-by-10-foot shacks, painted in brilliant colors and used as headquarters for a number of drilling companies.

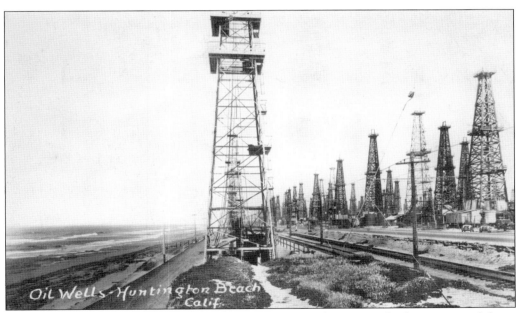

In this interesting 1930 postcard, the wells are visible as are the train tracks that ran up and down the coast. Evidence of gas and petroleum in the area goes all the way back to prehistoric days. Indians used pitch from the bogs to waterproof their baskets and reed boats. The Spaniards used oil for fuel and medicinal purposes as well. Little did they know what would come many years later.

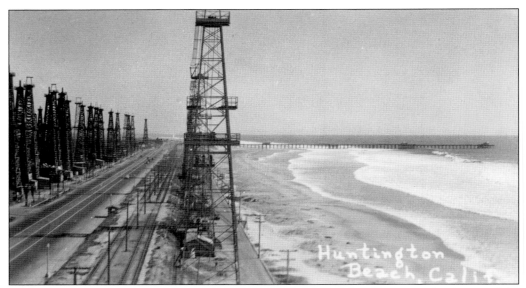

This unique 1940s angle, actually snapped from one of the tower perches, shows the density of the towers adjacent to the beach and provides an interesting view of the pier in the distance. During the war, the U.S. Army set up a radar post and searchlight here; the site of the Bolsa Chica Gun Club was fortified; and batteries 155, 128, and 242 included concrete bunkers and long-range guns. There were 155-millimeter guns, a bomb shelter, and a tower camouflaged as an oil rig. (Courtesy of Aaron Jacobs.)

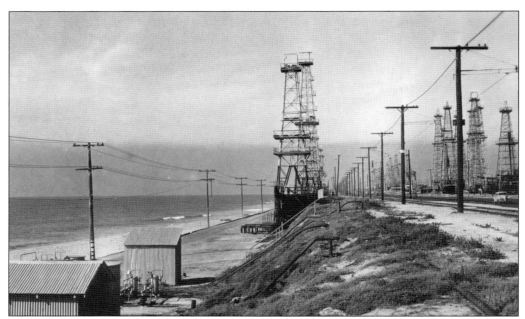

This 1940s view looks toward Long Beach down Pacific Coast Highway. at Seventeenth Street. Today, on a clear day, the Queen Mary and Spruce Goose dome in Long Beach can be seen from here, as well as much of downtown Long Beach.

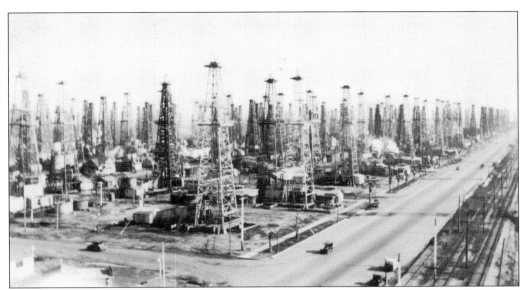

This postcard was sent to East Troy, Wisconsin, on February 6, 1928. The inscription reads, "Down here for the weekend. This town ruined by the oil wells. Just love the ocean, it is so fascinating. Tell Carolyn I will write her soon. Kindest regards."

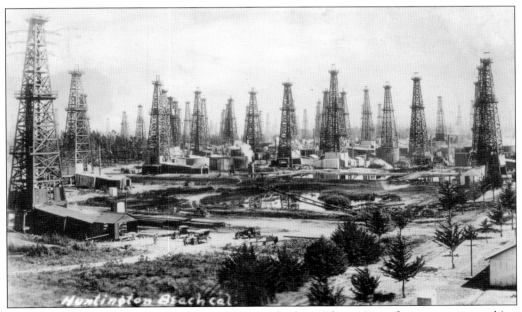

This card dates back to the mid-1920s and was sent back to Gilman, Iowa, from someone working in the oil fields. It states, "Hello old pal. How would you like to own some of this land with the oil wells on it? I am working on this field. I do the cementing here. I would like to see you. If you ever come out I'll show you a good time. How is your family? I have a boy and a girl."

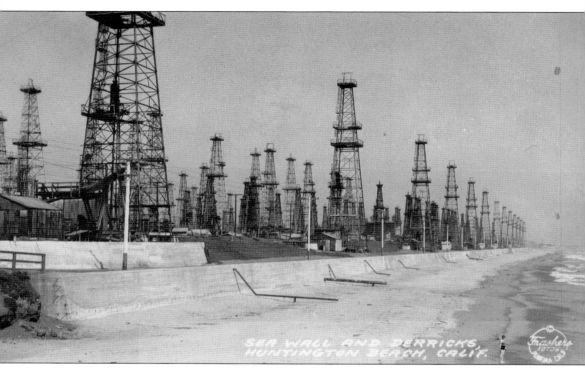

This 1949 postcard gives a good view of just how close to shore the 120-foot towers were situated. A month after the first oil strike in 1920, the population of Huntington Beach grew from about 1,500 to more than 6,000 as oil workers and businessmen flooded the city. Oil derricks sprung up all over town. Early residents even moved their homes to make way for drilling.

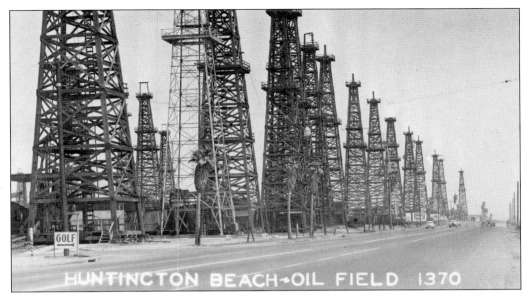

HUNTINGTON BEACH-OIL FIELD 1370

The "Golf" sign in this 1940s image points toward the Huntington Beach Municipal Golf Course that used to sit just north of Seventeenth Street and Palm Avenue. This shot is where Seventeeth Street meets Pacific Coast Highway.

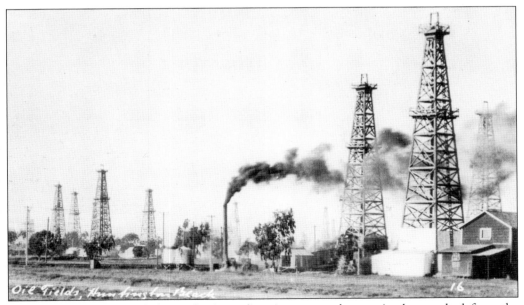

This early 1920s postcard shows the immediate impact on the terrain that resulted from the discovery of oil. During the oil boom years of the 1920s, Huntington Beach developed the surrounding territory near the beach. In 1925, Pacific Coast Highway was built, giving people better access to the beautiful beach.

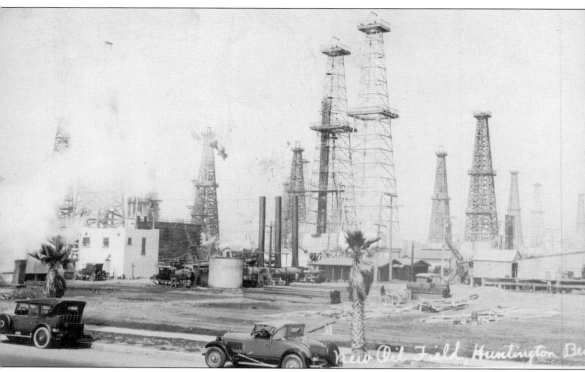

This is a 1930s image of the area that would become Pacific Coast Highway. Wells sprang up overnight for years in Huntington Beach. After a final oil strike in 1953, the fire department began clearing out derricks within the city and along the coast to make room for the population explosion that began in the 1950s.

Five

SCHOOLS, LIBRARIES, AND A TENT CITY

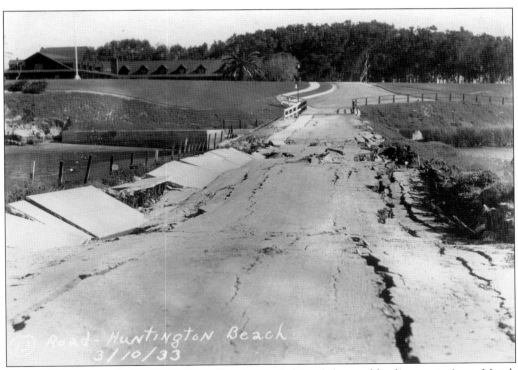

Pictured here is the Bolsa Chica Gun Club (upper left) and the road leading up to it on March 10, 1933, the day the infamous 6.25 magnitude Long Beach earthquake struck. The devastating quake damaged the pier, city hall, the old fire station, the First State Bank building, and many other local structures. (Courtesy of Aaron Jacobs.)

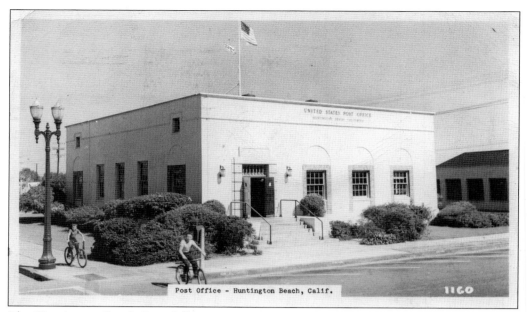

Post Office - Huntington Beach, Calif. 1160

The Huntington Beach Post Office at 316 Olive Street was a Works Progress Administration (WPA) project that opened in 1935. Today the building retains all of its architectural integrity and is one of the last historic structures left on Main Street. Interestingly enough, a sister building exists in Santa Paula, California—an exact replica of this one—built the same year. (Courtesy of Aaron Jacobs.)

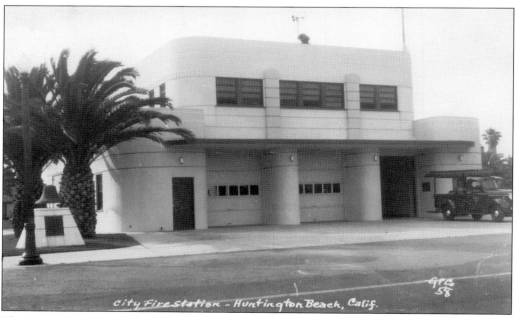

City Fire Station - Huntington Beach, Calif.

This is the Huntington Beach Fire Department in the 1940s. Located at Fifth and Main Streets, it was completed in 1939. This station, valued at $20,000, only cost $7,500 to build due to assistance provided by the WPA.

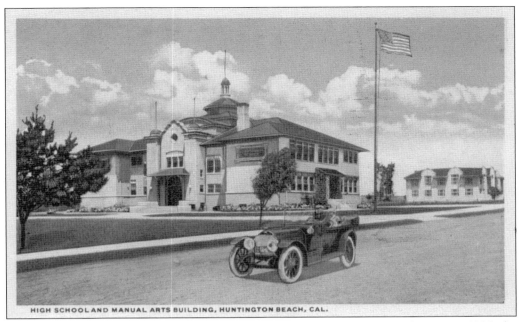

HIGH SCHOOL AND MANUAL ARTS BUILDING, HUNTINGTON BEACH, CAL.

An artistic rendering of the original high school takes postcard form around 1925. In 1921, the Huntington Beach Company increased mining in abundant oil fields around the city, bringing a wave of prosperity to the area. Oil derricks were located in the fields north of the school, which was in the area of the original Huntington Beach oil strikes.

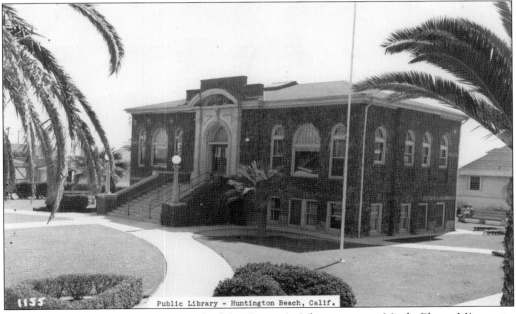

1155 Public Library - Huntington Beach, Calif.

The inscription on this 1950 postcard of the Carnegie Library, sent to Maple Plaun, Minnesota, reads, "Hi, Min. We are enjoying sunny Calif. I hope you are feeling much better by now. Will be back home day after new year. Art."

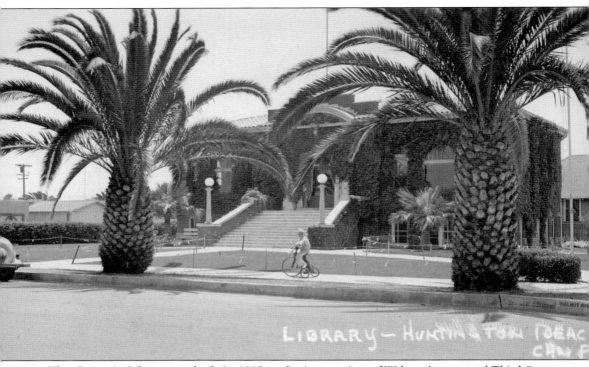

The Carnegie Library was built in 1913 at the intersection of Walnut Avenue and Third Street. In March 1933, it suffered considerable damage in the great earthquake that struck the area. On Friday, July 13, 1951, the Carnegie Library closed its doors after almost 40 years of service and soon after, a new library building at 525 Main Street was dedicated by Mayor Vernon Langenbeck.

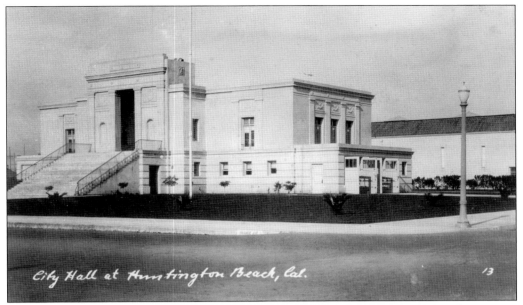

Pictured here is city hall around 1930. Located at Fifth Street and Orange Avenue, this site was used earlier for one of the first grammar schools in Huntington Beach.

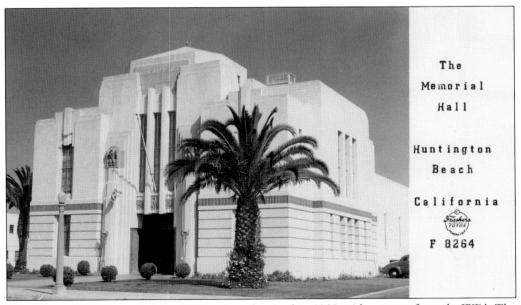

The Memorial Hall was built in 1933 and modernized in 1939 with support from the WPA. The building was designated the home of the American Legion Post 133, and during World War II, their members, along with the National Guard, used the top of the building as a lookout post to search for incoming enemy aircraft. From this perspective high above the city they could also assist local officials in enforcing blackouts intended to thwart visual navigation from enemy ships at sea. The building was torn down around 1970.

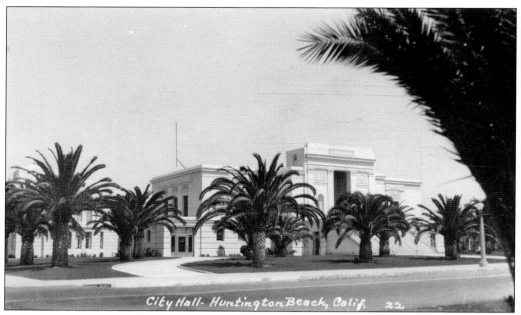

This is the old Huntington Beach City Hall. The structure was built in 1923, remodeled in 1939, and demolished in the late 1970s. Today a bike shop sits on the approximate area.

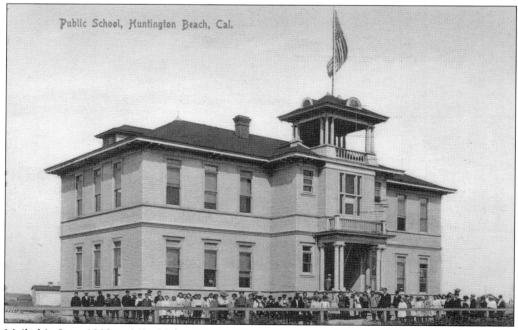

Mailed in June 1909 to Miss Helen Dix in Minnesota, the sender writes, "If you lived here this is where you would learn to get wise. Will make you a book when you are older. Aunt S."

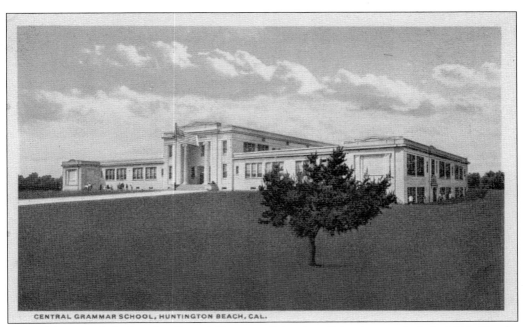

CENTRAL GRAMMAR SCHOOL, HUNTINGTON BEACH, CAL.

A *c.* 1920 postcard depicts the Central Grammar School on Palm Avenue, built in 1916. On the back of the card, the Huntington Beach Company advertises, "Write us for an illustrated booklet, entitled *Huntington Beach, the Garden Beach.* Just 32 miles south of Los Angles, Huntington Beach has the best beach front and the finest all-the-year climate in America."

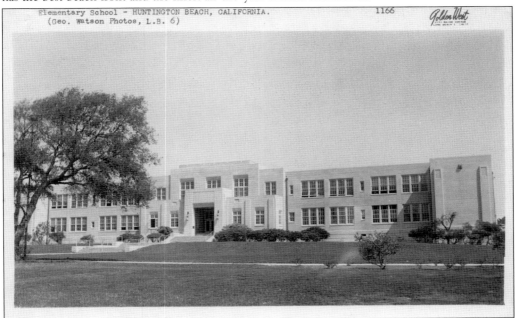

Elementary School – HUNTINGTON BEACH, CALIFORNIA. 1166
(Geo. Watson Photos, L.B. 6)

The Long Beach earthquake, which took place on March 10, 1933, exacted a large toll on nearby Huntington Beach. There were 119 fatalities, and widespread damage occurred in buildings, homes, and schools, including the Central Grammar School pictured here in 1954. It was rebuilt with a new, earthquake-proof design in 1935. Today it is named the Ethel Dwyer Middle School.

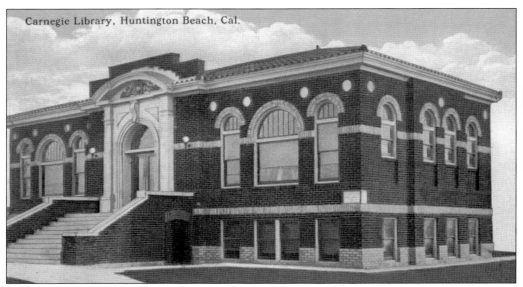

Carnegie Library, Huntington Beach, Cal.

In February 1913, Huntington Beach received notification that the Carnegie Foundation had granted the community $10,000 for a new library. In August 1913, the Carnegie Corporation accepted the plans and W. D. Lambert of Long Beach received the contract to build it. This postcard of the library dates back to about 1920.

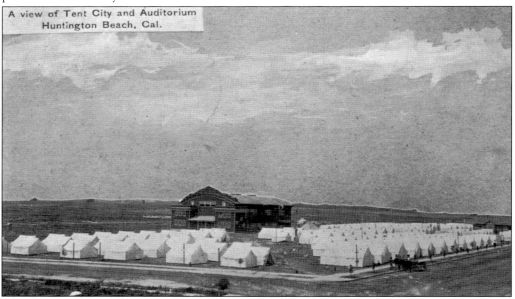

A view of Tent City and Auditorium Huntington Beach, Cal.

This is a view of the Methodist encampment. The postcard is postmarked July 1909, and a message sent to someone in Shell Lake, Wisconsin, reads, "Dear Friend, this is a picture of the place that we are now camped and attending meetings. I tell you it is fine. Dr. Torey is the evangelist. Wish you folks were here too, will be glad to hear from you anytime. All are well, with best wishes." In 1906, city boosters attracted the Methodist convention away from Long Beach by giving up a large campsite and then building a 3,000-seat auditorium for that denomination. For more than 10 years, visitors and residents flocked to the gospel meetings held here each summer as well as other conventions like those of the Grand Army of the Republic (GAR).

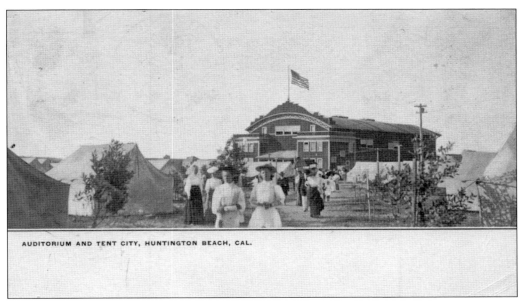

AUDITORIUM AND TENT CITY, HUNTINGTON BEACH, CAL.

This view of the Methodist encampment features the tabernacle auditorium. Postmarked August 1908, it was sent to Whittier, California, and the brief message on back reads, "Afternoon. Dear Mother, the ocean is beautiful. We have a tent; may stay until Monday. With love, Ellen."

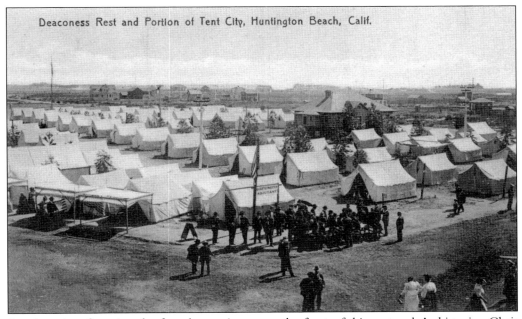

Deaconess Rest and Portion of Tent City, Huntington Beach, Calif.

Another view featuring the famed tent city graces the front of this postcard. As historian Chris Jepsen details, "The Methodist Tabernacle stood at what is now the intersection of Pecan and Twelfth Street. It was the centerpiece of a four-block campground or 'Tent City,' which was used for Methodist revivals, Grand Army of the Republic encampments, and vacationers who wanted affordable lodging near the beach."

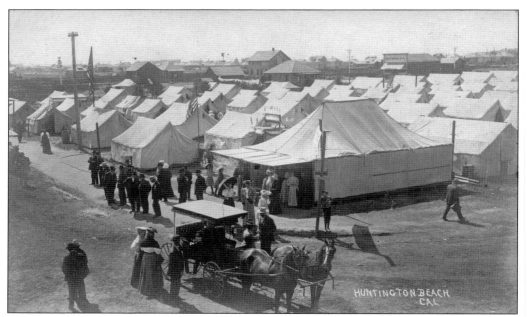

This is a closer shot of the tent city, taken around 1908. A message on the back of this card, which was sent to Danbury, Iowa, reads, "This is the M. E. camp ground of Southern Cal. We were down to the E. L. convention. It is a new place and mostly sand and ocean yet, but we had a good time. Amy."

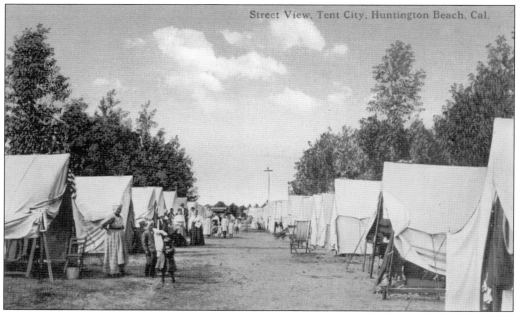

This *c.* 1910 postcard provides yet another angle of the tent city. During the summers between 1905 and 1920, as many as 15,000 people gathered to hear major speakers and participate in Bible study.

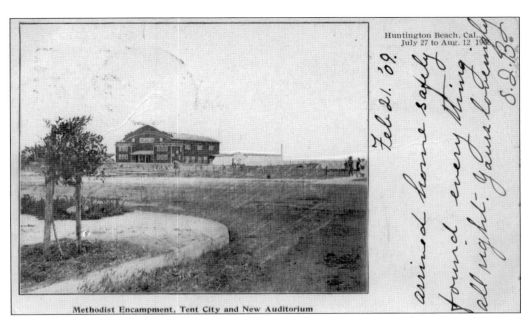

Huntington Beach, Cal.,
July 27 to Aug. 12 19

Feb 21. '09.

arrived home safely
found every thing
all right. yours lovingly

S.D.B.

Methodist Encampment, Tent City and New Auditorium

Written in the margin of this postcard that is dated February 21, 1909, is the message, "Arrived home safely found everything all right—yours lovingly." It was mailed to Santa Ana, California. Interestingly enough, Huntington Beach was incorporated February 17, 1909. Was the writer concerned that something might not be all right after returning home four days later?

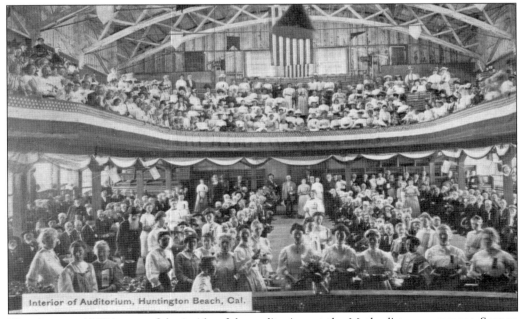

Interior of Auditorium, Huntington Beach, Cal.

Here is a rare 1909 image of the inside of the auditorium at the Methodist encampment. Sent to someone in Pasadena, California, it reads, "My dear friend, this is taken of a birthday shower so may you live to see many more."

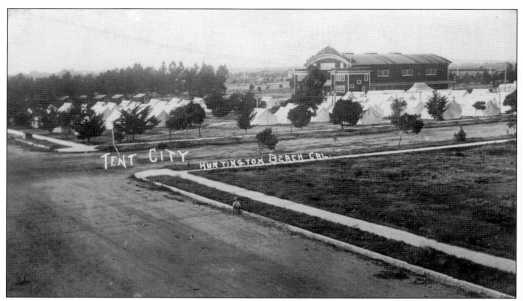

Postmarked August 1912, this postcard was sent to Corona, California. Though the handwriting in the body of the note is hard to decipher, it finishes with "7 p.m., camp is breaking up, leave in morning for L. A. at 9:48."

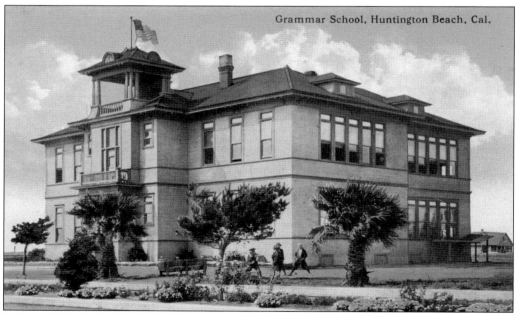

This is a 1910 postcard of First Grammar School. Located at Fifth Street and Orange Avenue, this site was used in later years for the construction of the new city hall.

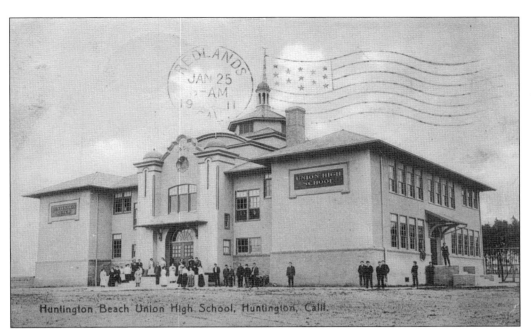

The first Huntington Beach Union High School is the subject of this postcard, built near the site of the current school. The first graduating class had four students. Postmarked January 24, 1911, the card was sent to Redlands, California. The inscription reads, "How is your dad? Everybody is getting along all right. It is raining like everything now. Mrs. Lee is as good as ever, only a little better."

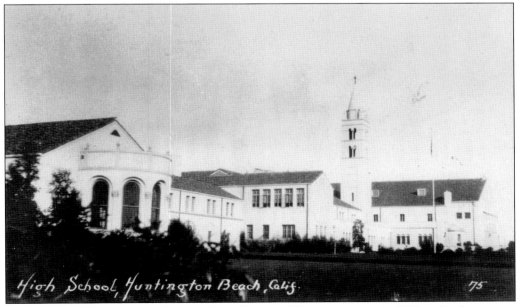

This is Huntington Beach High School just after rebuilding the campus in 1926. A simple message on the back of the postcard states, "I spent four years packed full of fun here."

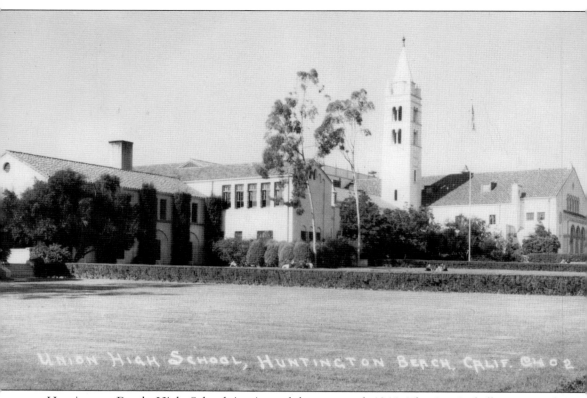

UNION HIGH SCHOOL, HUNTINGTON BEACH, CALIF. 8402

Huntington Beach High School is pictured here around 1945. The iconic bell tower and auditorium (far right) were the first buildings constructed for the new Huntington Beach High School campus in 1926. They were designed by Orange County's pioneer architect Frederick Eley and the Orange County firm Allison and Allison, who described the school's design as a Lombard Romanesque Revival. The rotunda (seen on previous page) and several of the other original buildings were replaced in the 1970s with more modern structures, but the clock tower and auditorium remain and were designated an Orange County Historical Landmark in 1987. In 2004, a bond measure passed, providing funds for much needed infrastructure improvements and construction of new buildings. Construction is ongoing in 2008.

Six

THE PEOPLE GIVE
THIS TOWN ITS CHARM

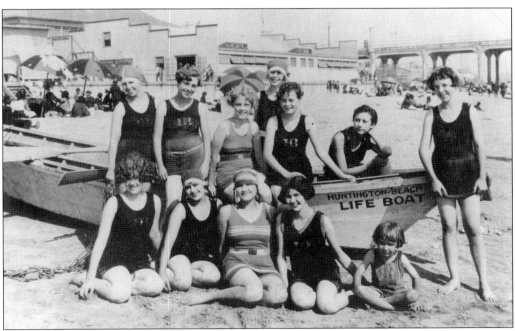

In 1918, Huntington Beach established lifeguard service by hiring its first lifeguards, Henry Brooks and Robert Nutt, to patrol the beachfront. Several of these women are wearing their lifeguard suits as they pose in one of the city's lifeboats near the pier. While there was not an official rule disallowing female employees, lifeguarding was considered by many to be a man's job. That said, the first female lifeguards were hired in the mid-1950s.

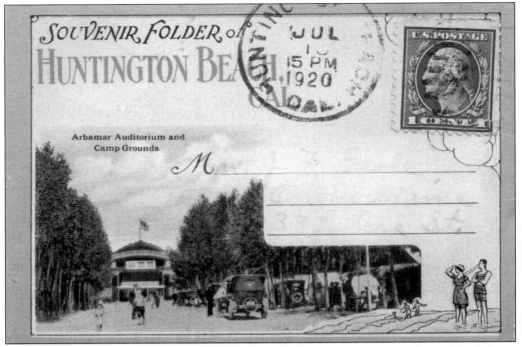

Souvenir Folder of Huntington Beach, Cal.

JUL 15 PM 1920

U.S. POSTAGE 1 CENT

Arbamar Auditorium and Camp Grounds

M

This charming booklet, postmarked July 1920, folds out and features a series of colorful miniature Huntington Beach postcards along with plenty of chamber of commerce promotional copy about what makes Huntington Beach a spectacular place to live.

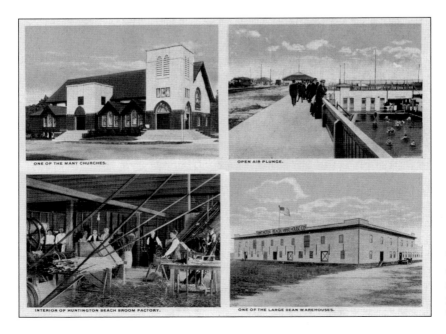

ONE OF THE MANY CHURCHES.

OPEN AIR PLUNGE.

INTERIOR OF HUNTINGTON BEACH BROOM FACTORY.

ONE OF THE LARGE BEAN WAREHOUSES.

This is an array of some of the mini-postcards included in the booklet.

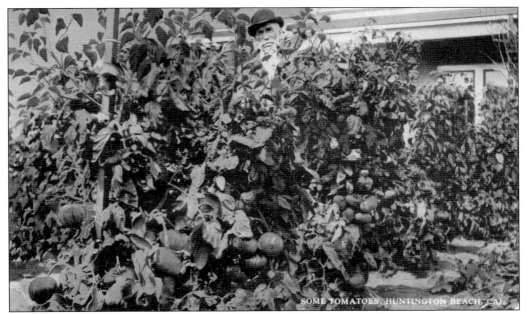

A sprawling backyard tomato patch is featured in this unusual 1915 postcard. The earliest real estate brochures seen from Huntington Beach boast of the unsurpassed, peat-enriched soil. "The richest land on Earth," as this gardener can attest to.

This family postcard is postmarked April 1911. Huntington Beach had been incorporated for just two years at this point, and in 1911 the first building ordinance was passed and formal records of the city's expansion began.

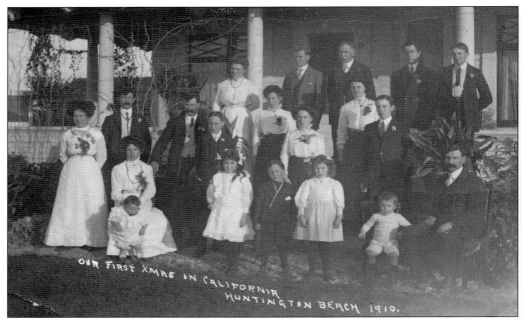

Pictured here is another family postcard, and as is noted on the front, this captures their first Christmas in Huntington Beach in 1910. A message on the back reads in part, "Dear Stan, This photo was taken on Boxing Day outside. You can see the sun is in our eyes. Lil was out driving in white, as you can see. Hal found it warm. It is a jolly fine climate. Please remember us to the Misses."

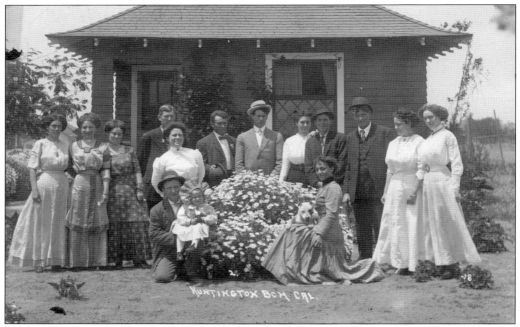

Back around 1910, when it is believed this shot was taken, families that had a little extra money could afford to invest in personal postcards of themselves to send to friends and family.

Another family poses for a postcard from Huntington Beach around 1910. Notes on the back of these often listed who was visible and what the occasion was.

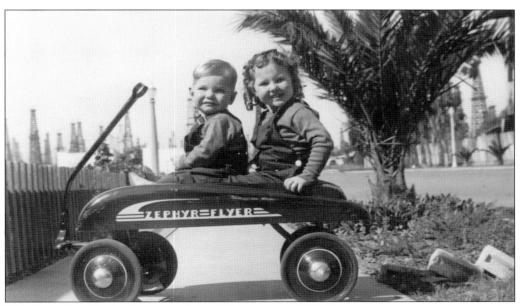

This is an adorable family postcard dated February 1, 1940. On the back, a handwritten caption reads, "Darlene and Dickie Williams in their new wagon in front of Grandpa and Grandma Williams house in Huntington Beach." Note the ever-present oil wells in the background.

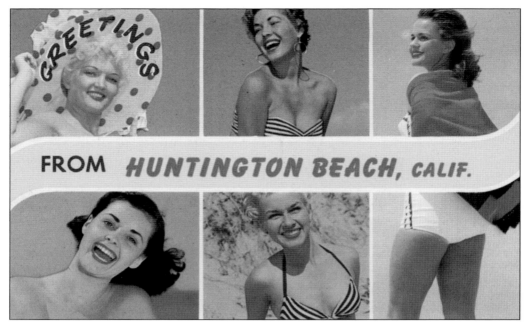

A kitschy, early-1950s postcard features a bevy of Huntington Beach beauties. It was around this time that the city's final oil strike came, in 1953 to be exact. This was near the old commercial area and resulted in removal of another, more modest residential area.

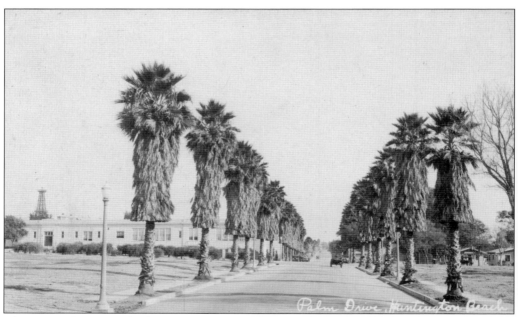

This postcard view is of Palm Drive at Seventeenth Street in the 1930s. Note the oil well on the far left. The presence of oil in Huntington Beach didn't come as a great surprise. Residents had used abundant oil and asphalt oozing up from the soil to repair roofs, and attempts at digging for well water sometimes yielded natural gas instead.

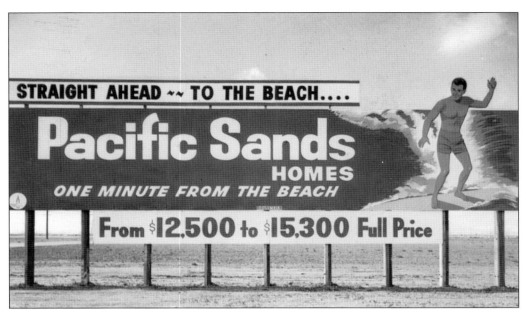

A minute from the beach for $12,500? That is such a deal. This postcard shows a billboard advertising the Pacific Sands tract on the 8100 block of Atlanta Avenue in Huntington Beach in the early 1960s. By then, the city had already assumed the role of "Surf City, USA."

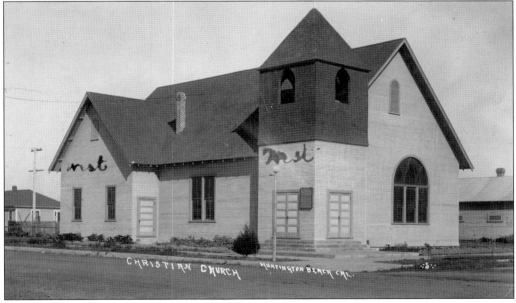

This is the Church of Christ around 1930. Just a couple of years after this, a third oil strike took place nearby. It had worldwide impact because of the new techniques it utilized. Up until then, drilling had been a nearly vertical endeavor, extracting crude directly over an oil pool. With the creation of controlled directional drilling, first used successfully here to tap the tideland pools, a well could be drilled on a slant in any desired direction. Within a year, 90 wells were producing from tall rigs along the coastline. These bobbing pumps remained the symbol of coastal Huntington Beach for many years. Now most are gone or masked by plantings.

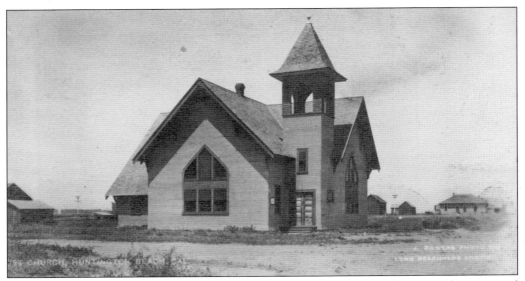

The church building at 401 Sixth Street was dedicated in 1906, the year this postcard was created and three years before Huntington Beach was incorporated. This is the oldest church building still standing in the city. In 1972, the building was purchased by a small group of faithful believers who then turned it into the Community Bible Church, which is still the name today.

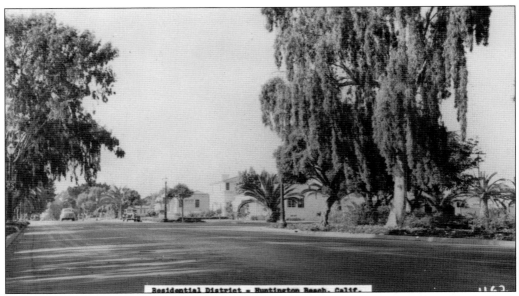

This is a 1950 postcard that depicts a typical residential street in Huntington Beach and looks like it may have been shot in the vicinity of Clay and Main Streets. Postwar Huntington Beach followed the same path of growth and prosperity that the country experienced during the 1950s. The city annexed additional land and grew from an original size of under 4 square miles to more than 25 square miles. The fire department cleared away hundreds of wooden oil derricks, while elsewhere new ones were built. Southern California Edison built an electrical generating plant as well.

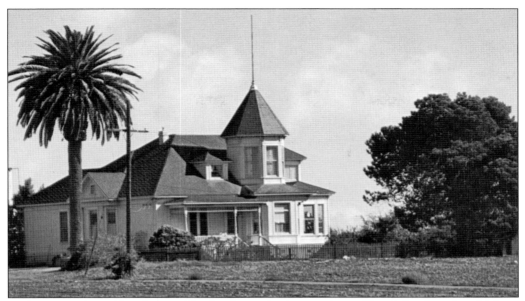

Built in 1898 by W. T. and Mary Newland near the intersection of Beach Boulevard and Adams Avenue, this beautiful two-story Newland farmhouse has been lovingly restored by the Huntington Beach Historical Society and is now listed on the National Register of Historic Places. The Newlands, one of the most notable families in the area, lived here for 54 years, and today tours of the house are offered. This postcard is from around 1940.

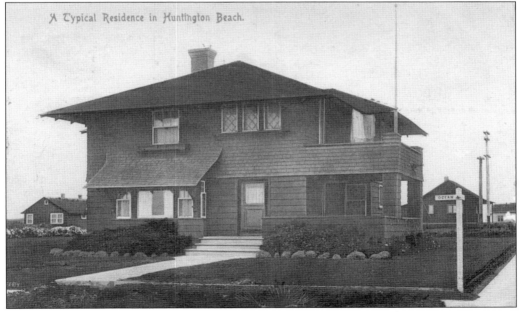

The front of this postcard states, "A Typical Residence in Huntington Beach." This particular residence is located on Ocean Avenue, right by the beach. It is postmarked July 1908, was sent to Los Angeles, and reads, "Having a grand time. Went in bathing twice already. It's fine down here. Not much doing though except meetings. We like it fine. You had better find out what time your car leaves Sat. night. With love from girlie."

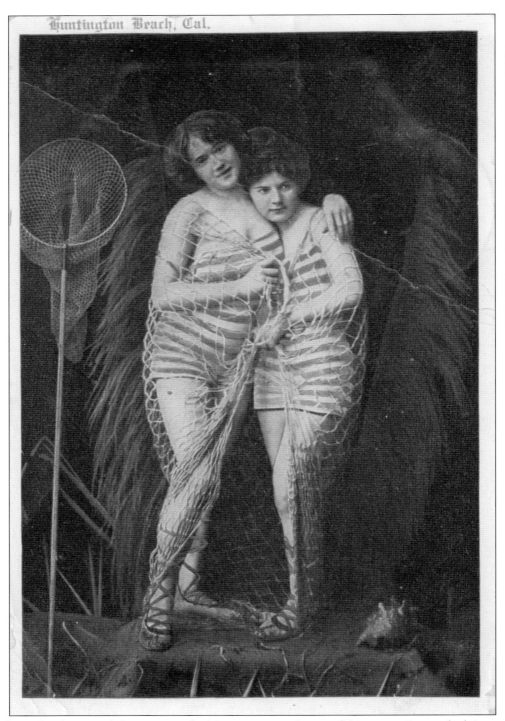

Huntington Beach, Cal.

This stylized postcard features two fetching women and some fishing nets. Postmarked August 1908, the message on the back of the card is simple and timeless, "Gals of this kind here. Wish you could see them."

Seven

LIFE IS A BEACH
NEAR MAIN STREET

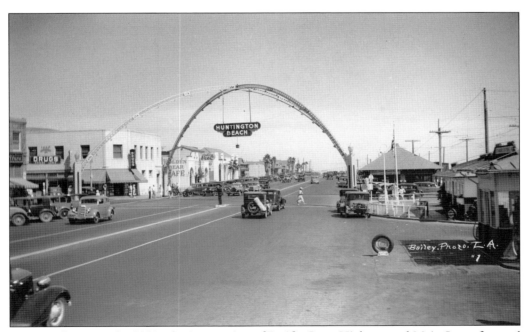

For several years in the 1930s, the intersection of Pacific Coast Highway and Main Street featured a decorative arch, often lit up and decked out for the holidays. It was taken down due to the constant upkeep created by the salty air. In this *c.* 1939 scene, in addition to the arch, the famed Golden Bear nightclub is clearly visible to the left.

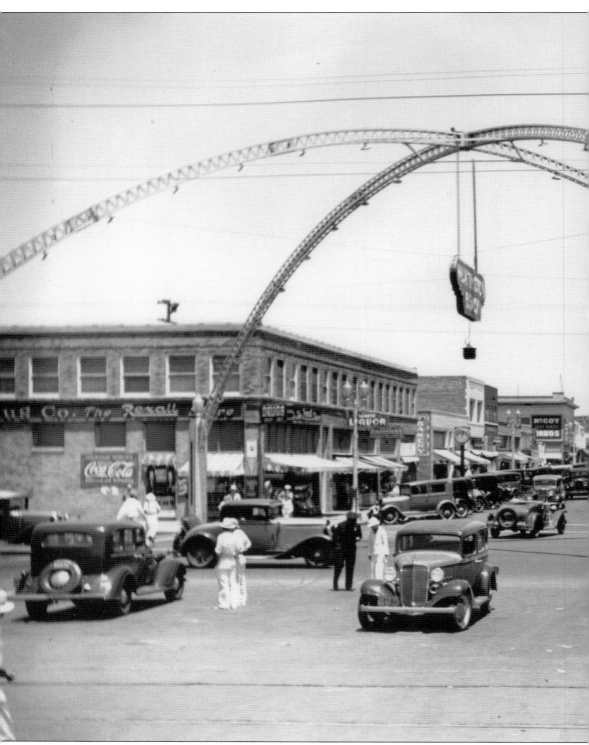

This 1930s image was taken from the popular angle of looking up Main Street from the pier.

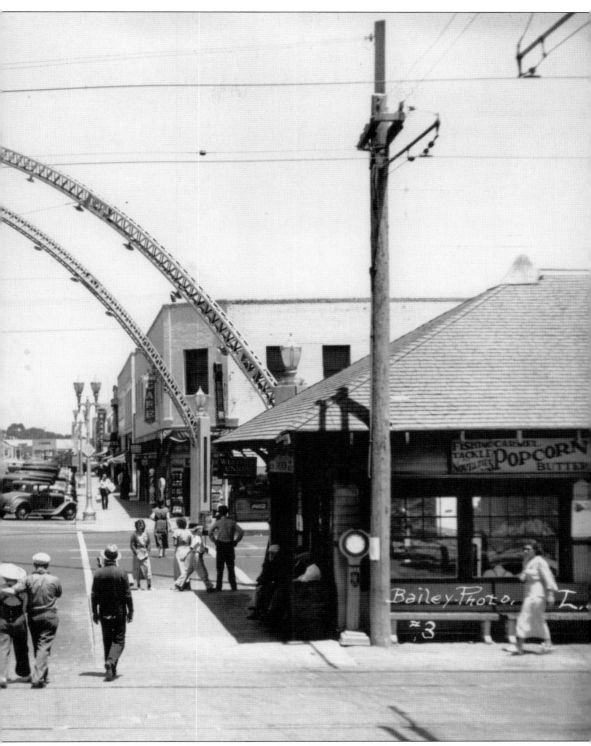

McCoy Drugs is visible near the center of the frame. (Courtesy of Randy and Sharon Lynn.)

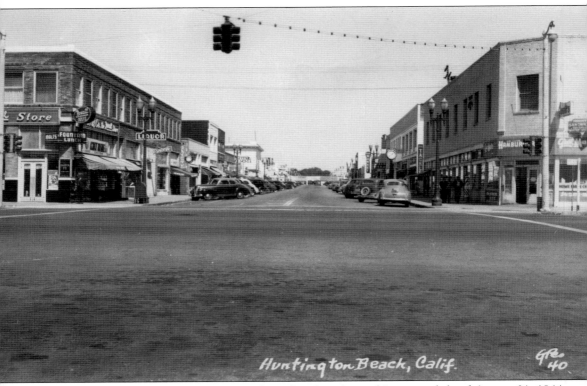

Another shot looking up Main Street from the pier adorns this postcard dated August 31, 1944 (2:30 p.m.). It is addressed to Holcomb, Illinois, and the message, written with elegant penmanship, reads, "Dear Mom, Happy Birthday. We are spending a few days here in our trailer. It's a lot cooler than home. Love, Ruth & Bake."

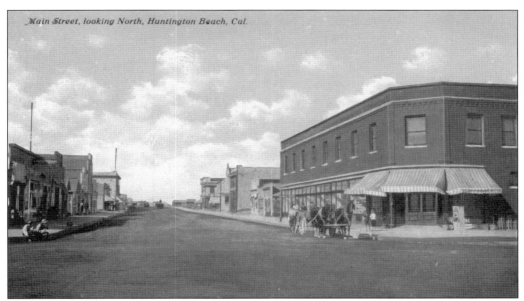

An early view of Main Street is captured here around 1910. A year before this, the city, which was about 3.5 square miles at the time, was incorporated. The population was just 915 people. City hall was a room between the bank and the post office where city trustees met and named Edmund Manning as the first mayor. Manning was originally from Illinois. At the age of 20 he headed west, ending up in Pacific City where he became a plumber, working on major projects in neighboring Newport Beach. One of his first acts as mayor was to start a volunteer fire department. He gave the task to John Philip, a hardware salesman who became the first fire chief.

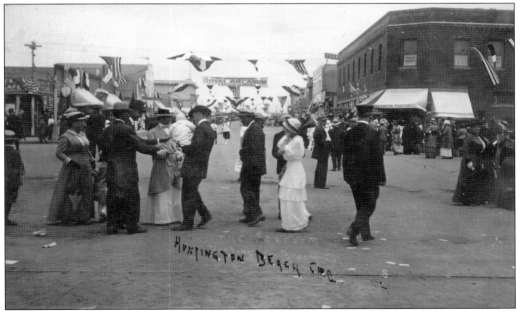

The Royal Arcanum is one of the oldest fraternal benefit societies in the United States and Canada that offers many social and community benefits to its members. It was founded in Boston in 1877, so the banner commemorating the 37th anniversary would place this postcard at 1914.

This postcard features a view looking down Ocean Boulevard, toward the pier, from about Ninth Street. The Pacific Electric Rail Depot is visible in the distance on the right. (Courtesy of Charles Sanders.)

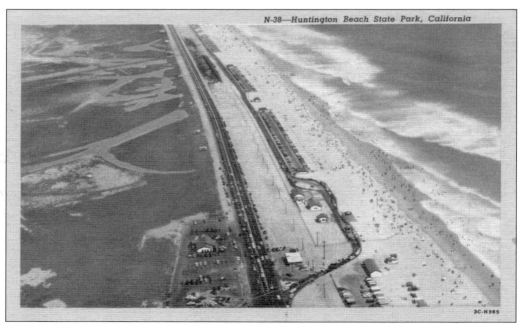

A 1930s aerial appears to show the area where today Beach Boulevard meets Pacific Coast Highway. Before this, Ocean Avenue stopped at Twenty-third Street in the north. Pacific Coast Highway was completed in 1926, and actress Mary Pickford cut the ribbon on opening day.

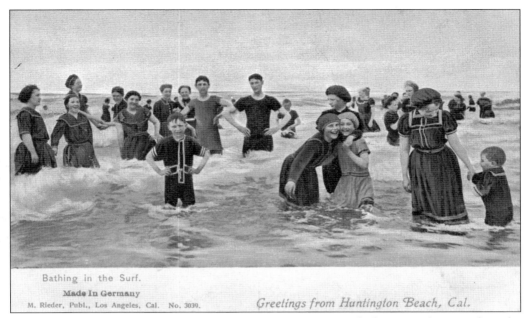

Bathing in the Surf.
Made In Germany
M. Rieder, Publ., Los Angeles, Cal. No. 3039. *Greetings from Huntington Beach, Cal.*

This classic, turn-of-the-century postcard features vintage one-piece bathing suits that were the order of the day. This attire almost seems more like full dresses for women. (Courtesy of Charles Sanders.)

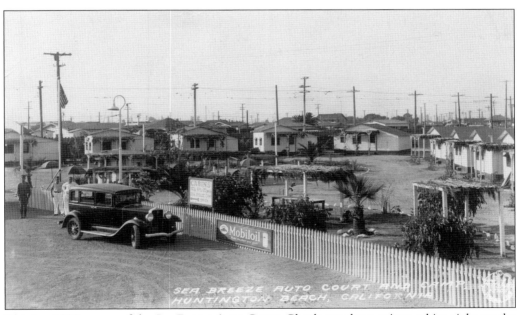

This is a 1930s scene of the Sea Breeze Auto Court. Check out those prices: cabins right on the beach for $1.00 to $2.50 a day. (Courtesy of Aaron Jacobs.)

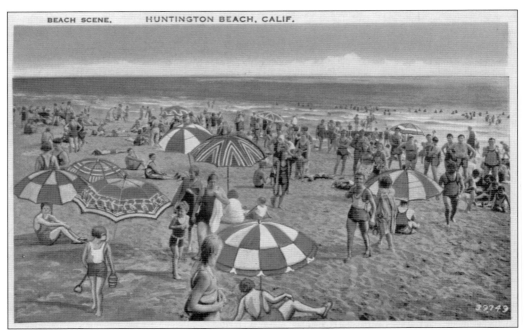

A colorful postcard from Huntington Beach, postmarked July 19, 1940, is addressed to someone in Los Angeles. The message reads, "Dear Margaret, will drop a line as we plan to come home Sat. or Sunday for a while. Will see you then. Do not make arrangements to come until you hear from us. Love, M. B. K."

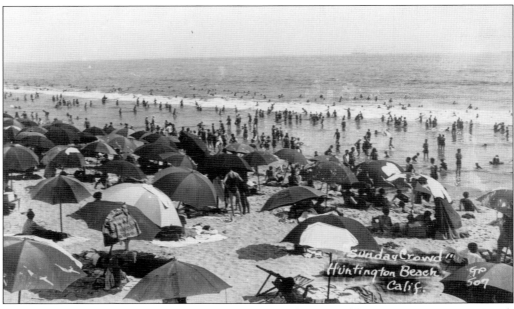

This postcard declares a 1940s beach scene as a "Sunday Crowd." By now, Huntington Beach was coming into its own. By the end of the 1940s, the city budget increased nearly a $100,000, reaching a record $604,394.

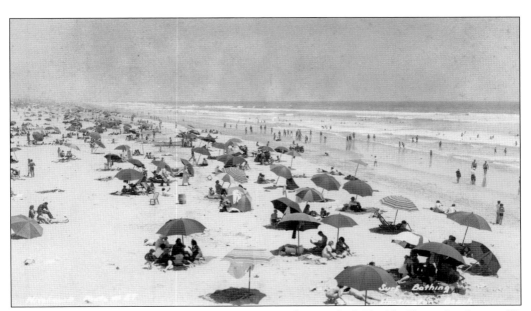

It is August 18, 1936, and Phyllis is sending a postcard to Sanford, Florida. She writes in part, "It seems good to be back in a green country. Traveling through L. A. now and will be back in Ga. Tomorrow. This is a typical scene on the beaches of California."

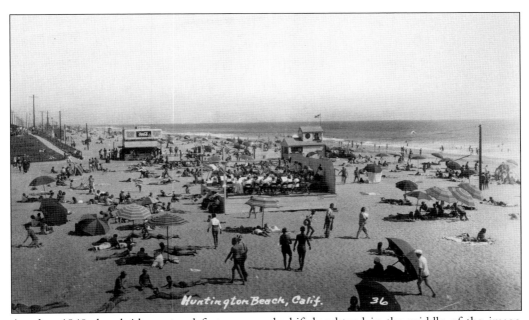

Another 1940s beachside postcard features a makeshift bandstand in the middle of the image. Free concerts were a popular form of entertainment that could frequently be enjoyed during the summers in Huntington Beach.

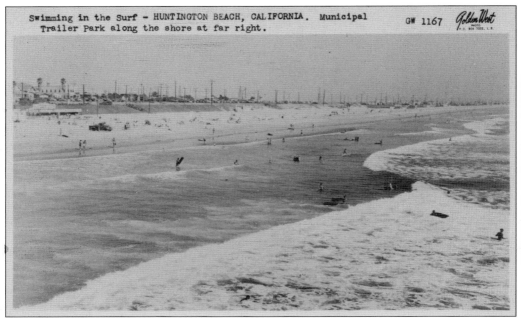

As the caption indicates, the Municipal Trailer Park is visible along the shore at the far right. This postcard is postmarked May 8, 1955, and there is a brief inscription on the back, "Dear Dell, Leaving California today. Will see you the end of the week. Jack and Blyth." It was sent to Dayton, Ohio.

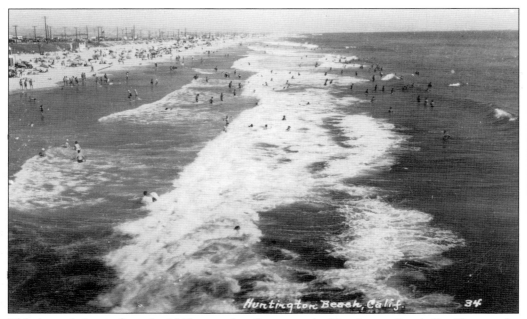

This dramatic image from the 1940s was taken from atop the Huntington Beach Pier. Topography is part of what makes the surfing conditions so exceptional in Huntington Beach. The beach is angled toward the southwest, and so the summer storms coming in from the Pacific result in near-ideal surfing conditions.

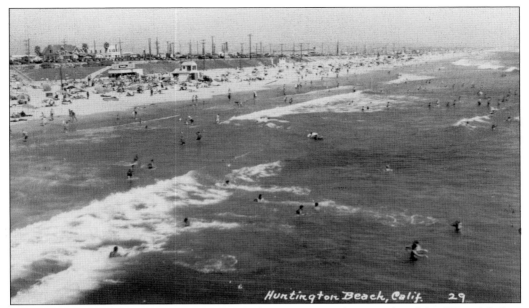

Postmarked September 6, 1946, Jayne is writing home to Pennsylvania and explains, "Dear Mother, this is where I saw the performance on Labor Day. A corner of the bleachers can be seen to the left. For some reason, no paddleboards are in use at this time. This was taken off the high pier that juts way out into the ocean."

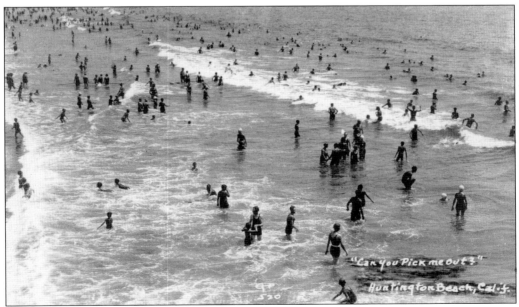

This 1940s postcard of Huntington Beach asks the reader, "Can you pick me out?"

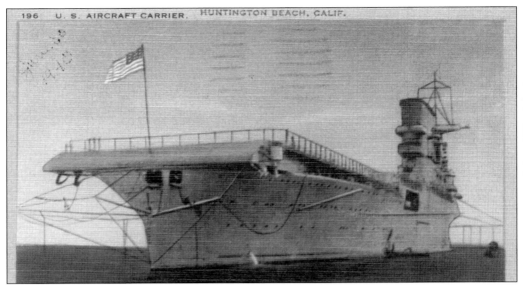

This is a U.S. aircraft carrier anchored off Huntington Beach. The message on the back of the postcard, postmarked July 30, 1940, reads, "When he first came to California, Harvey was a guest on the U.S.S. Lexington aircraft carrier, what you see here on the other side of this card. We saw the huge kitchens, the bunks, libraries, the auditorium where the sailors see their movies + indoor plunge that the sailors have for sport. Write when you can. Be careful. Love, Lucille." The card was sent to Bellefontaine, Ohio. Today the USS *Lexington* is a floating museum near Corpus Christi, Texas.

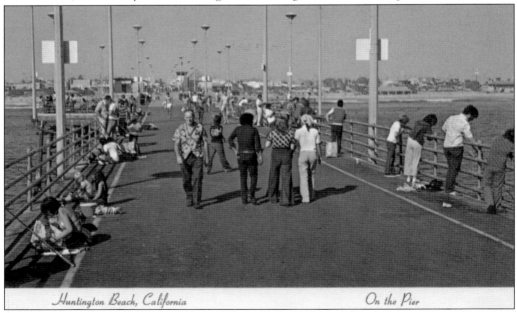

Huntington Beach, California *On the Pier*

This is a more recent postcard of the Huntington Beach Pier in the 1980s. In March 1983, storms tore the end of the pier off, sending it and the popular End Café restaurant into the ocean. Soon, a new two-story End Café would be overlooking the Pacific. But on January 18, 1988, a large winter storm once again destroyed the End Café and a large section of the pier. A 1940s-themed Ruby's Diner now sits at this scenic location.

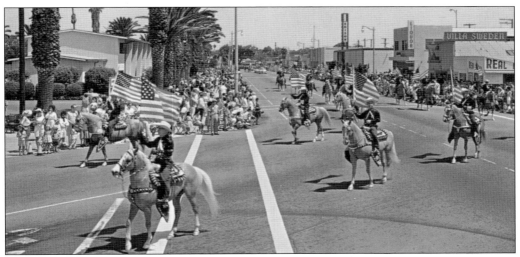

The annual Fourth of July Parade in Huntington Beach has become the stuff of legend; it is one of the most famous and continuous parades held in the United States. It began in 1904 to commemorate the arrival of the first electric passenger train, with attendance estimated at 50,000. In this 1970s postcard, the popular Villa Sweden restaurant is visible on the right. Unfortunately today it is gone.

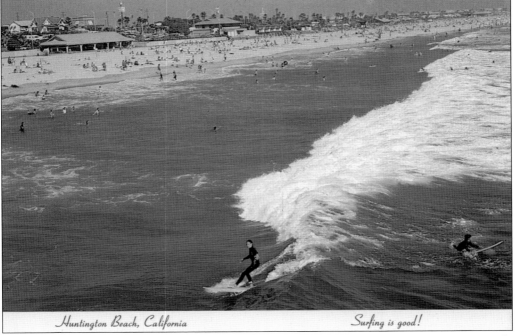

Huntington Beach, California *Surfing is good!*

"Surfing is Good!," as this postcard declares, could easily be the motto for Huntington Beach. Surfing history runs deep in Huntington Beach. In 1925, Duke Kahanamoku brought the sport to the city and other Southern California shores. Huntington Beach's first surf shop, Gordie's Surf Boards, opened in 1953. Six years later, the first U.S. Surfing Championships were held in Huntington Beach. The following year, the surfing championships were covered on television, which crystallized Huntington Beach's international fame as a surfer's haven.

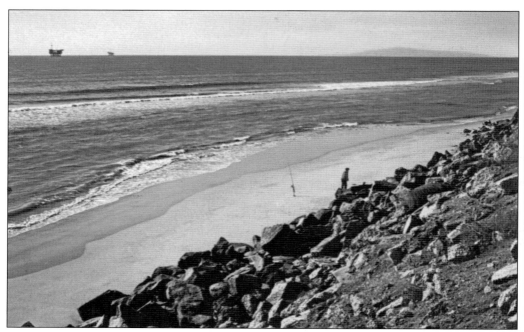

This is a solitary, early-1960s image of a fisherman near the present-day location of Dog Beach, where dogs are allowed to run free on the beach without a leash. Long Beach can be seen in the distance to the right; an oil platform is out at sea to the left.

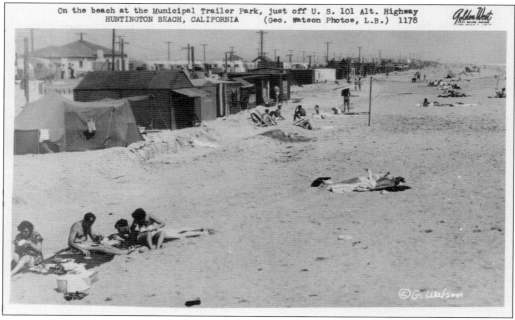

On the beach at the Municipal Trailer Park, just off U. S. 101 Alt. Highway HUNTINGTON BEACH, CALIFORNIA (Geo. Watson Photos, L.B.) 1178 Golden West

Camping on the beach at the Municipal Trailer Park was a common sight. Throughout the 1930s, this section of beach became very developed and popular. People were starting to bring trailers to park on the grounds, resulting in the creation of the Municipal Trailer Park. In 1959, the park closed down, which was a sad day for many locals.

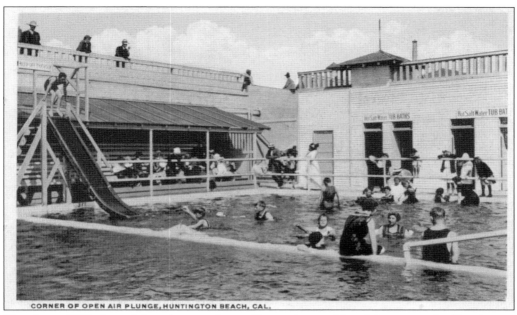

CORNER OF OPEN AIR PLUNGE, HUNTINGTON BEACH, CAL.

Here is a *c.* 1912 shot of the saltwater plunge. Due to how cold and dangerous the Huntington Beach surf could be, many opted for the heated, soothing waters of the saltwater plunge. Located just on the north side of the pier, it was a necessity in this small rural town, because many homes lacked indoor plumbing.

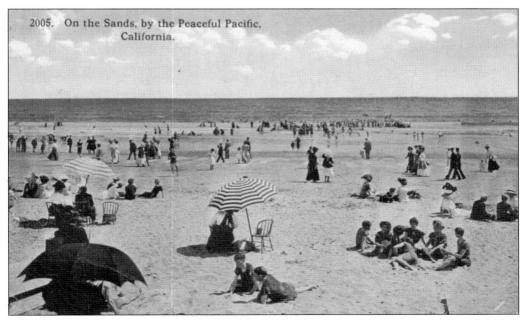

2005. On the Sands, by the Peaceful Pacific, California.

This vintage postcard is postmarked August 20, 1915, and a message, written in German, describes how wonderful and warm the ocean is. The card was sent to Visalia, California. Note all of the old-fashioned, one-piece bathing suits, hats, and other modest clothing of the day.

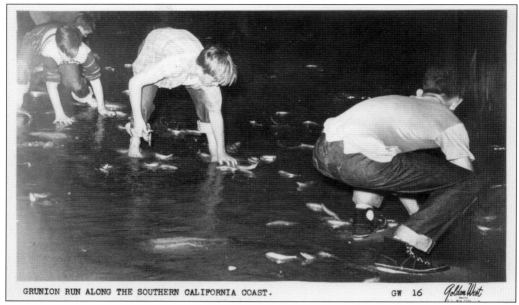

GRUNION RUN ALONG THE SOUTHERN CALIFORNIA COAST. GW 16 *Golden West*

Grunion are unique fish that swim to shore and lay their eggs in the sand during nights of the highest tides in spring and summer. The eggs stay in the sand for about two weeks before hatching during another high tide. Tasty when fried, these little fish can be caught by anyone under age 16 or adults with a fishing license. To protect the species, there are some rules, but not too many to take away the fun. Nets may not be used and holes cannot be dug to catch the grunion, only what can be picked up with bare hands may be kept.

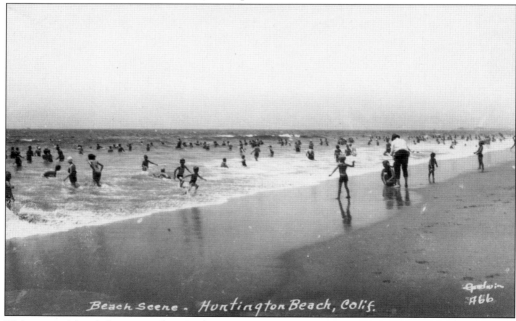

Beach Scene - Huntington Beach, Calif.

This ground-level shot was taken in the 1940s. On the beach at this time, you would have been near oil fields, the Huntington Inn, the Saltwater Plunge, the Talbert house, the original pavilion, the pier, Dwight's snack stand, and many other local hot spots.

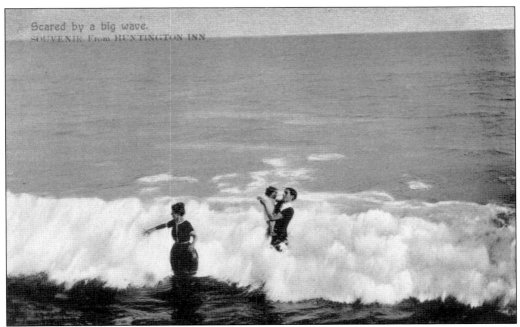

This is a *c.* 1905 "Scared by a big wave" souvenir from Huntington Beach. It was in this year that the Huntington Inn was built at Ocean Avenue and Eighth Street. Lots in the area that previously sold for $1,000 to $2,000 were now selling for $3,000.

The postmark on this postcard is May 24, 1945. Dottie is writing Marice in Pasadena, California, "Hi, 'Baby'—Having lots of fun! Boy am I burned! I'll be glad to get home! Have a swell cabin + lots of good fun, eats & beach! I'll call you when I get home."

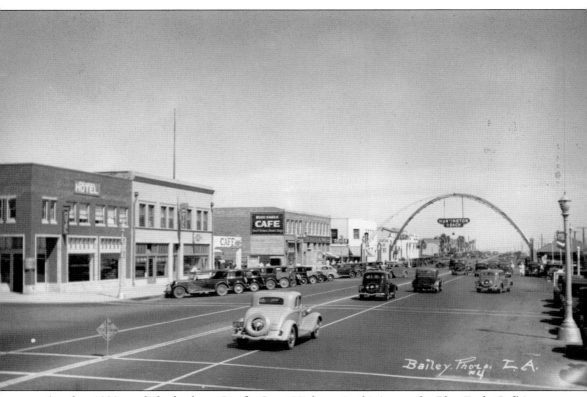

Another 1930s angle looks down Pacific Coast Highway. In this image, the Blue Eagle Café is seen to the center left and the Golden Bear can be made out just to the left of the arch and a few doors down from the Blue Eagle. (Courtesy of Randy and Sharon Lynn.)

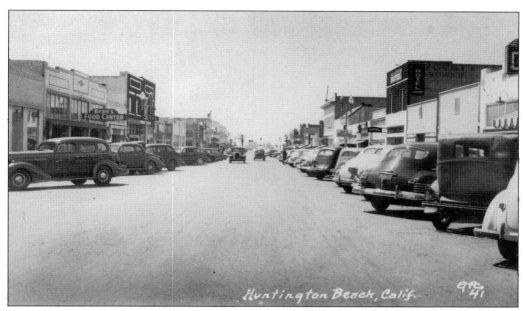

This 1940s image is looking out toward the pier down Main Street, which was the bustling downtown in the post-oil years. Geologists in the 1930s estimated there were seven million barrels of oil underneath Huntington Beach, but they were off by a bit. By 1980, Huntington Beach had produced one billion barrels of oil, and a 2001 report estimates there are another billion barrels offshore.

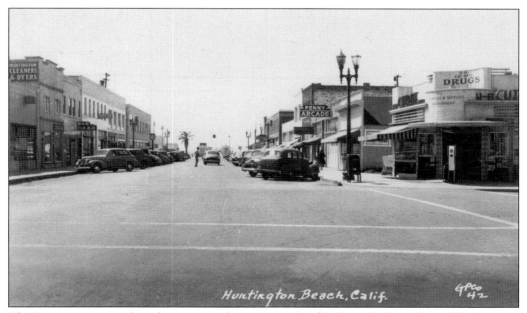

This image appears to have been snapped just moments after the one above, but a block or two closer to the pier. It gives one a good idea of how Huntington Beach in its pre-tourism days was simply a snapshot of small town America. This is where a person would find the cleaners, a hardware store, and cafés—all basic local services.

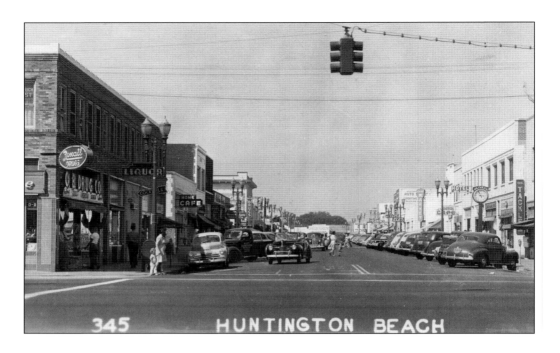

This 1948 postcard looks up Main Street from the pier. Sometimes the back of a postcard can be just as interesting as the front. The inscription on the back of the above card reads, "Hi, Wally. Well, we finally arrived here in one piece and our faces are quite red tonight. My cold is worse and with a sunburn I have quite a lot of trouble. Harry Aburmand came to see us. Well g'nite from one 'lil' red one. Shirlee."

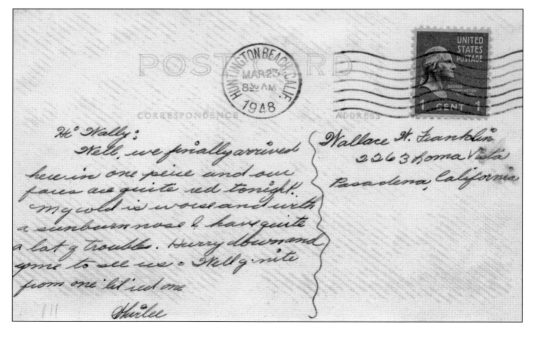

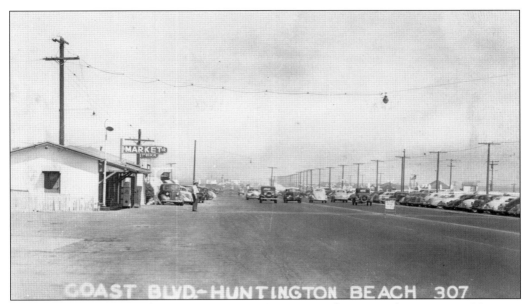

This is a Pacific Coast Highway scene in the late 1930s. This postcard was sent to Newport News, Virginia, and an inscription reads, "Hi, Jen. The weather's fine here. Going in swimming pretty soon with Pops. Wish I'd have taken the train home. I'm black and blue with bruises. The bus was loaded. I want to write to little Helen so please send me her address. Write to me, hear? Love, Margaret."

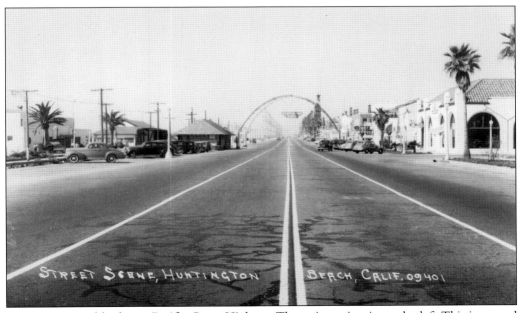

A 1930s postcard looks up Pacific Coast Highway. The train station is on the left. This is a good example of how the Main Street arch welcomes those who enter the community.

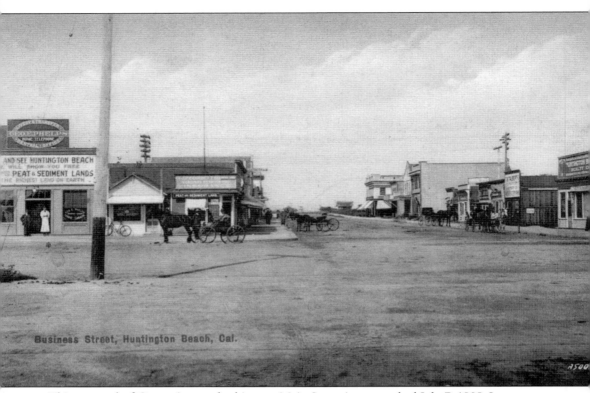

Business Street, Huntington Beach, Cal.

This postcard of Ocean Avenue looking up Main Street is postmarked July 7, 1908. It was sent to Pasadena, California, and reads, "Dear Miss Boehmer, Can't you and Miss Lydia come down next Sat. and stay over Sunday. Either that or the next Sat. + Sunday. I hope to see you girls both on the 11th. With love from Emma."

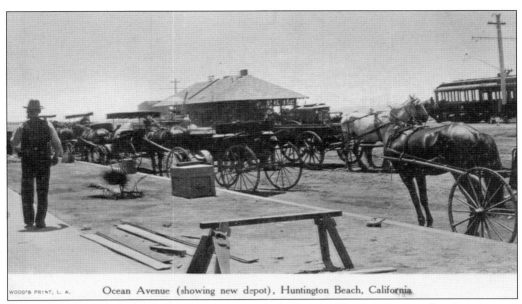

Ocean Avenue (showing new depot), Huntington Beach, California

WOOD'S PRINT, L. A.

As this rare postcard states, this is Ocean Avenue, which is visible in the center showing the new depot. A train can be seen in the distance a little right from center in this *c.* 1905 image.

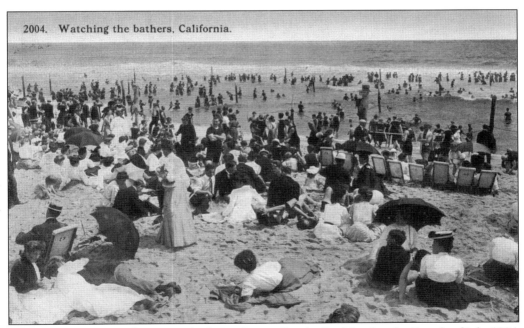

2004. Watching the bathers, California.

An early-1900s image shows a packed Huntington Beach. On Monday, the Fourth of July, 1904, a crowd estimated at 50,000 witnessed the dedication of the City of Huntington Beach and the arrival of the first Pacific Electric Red Cars.

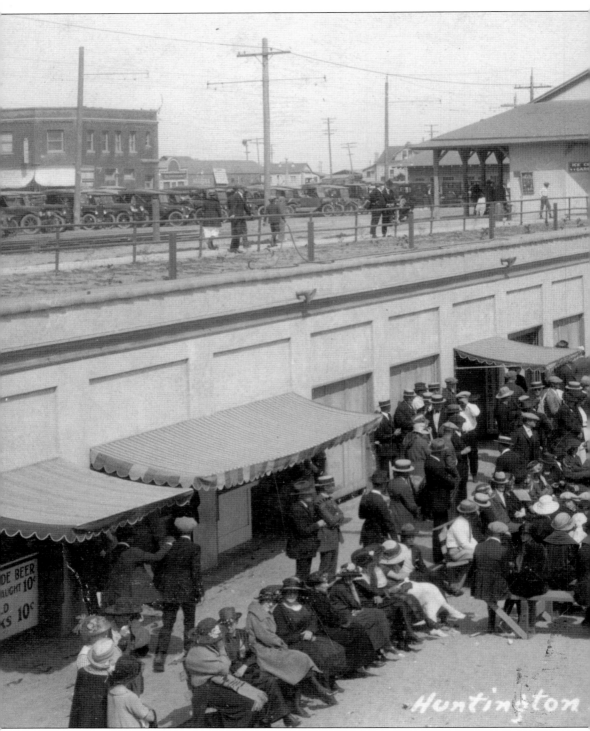

This image was taken next to the pier just below the train station (center) around 1912. It was in 1912 that a large storm damaged the old wooden pier, but a bond voted on by the citizens helped

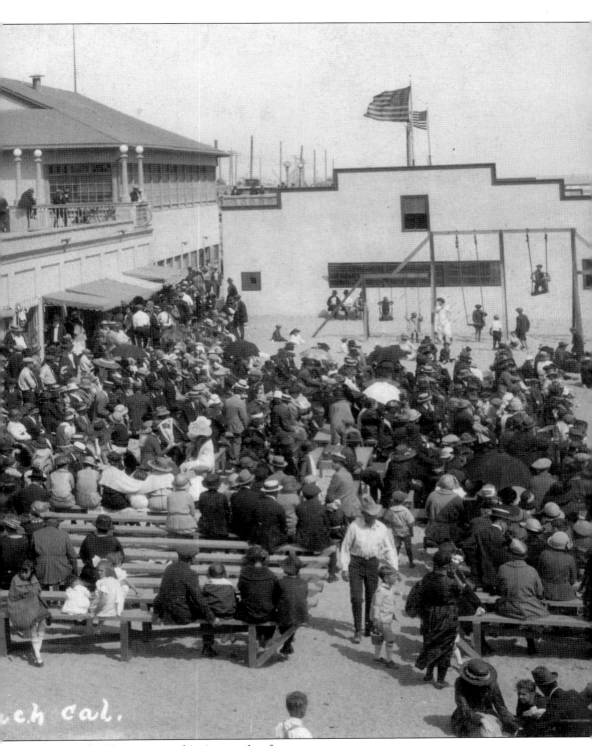

ch cal.

the city rebuild a new one, this time made of concrete.

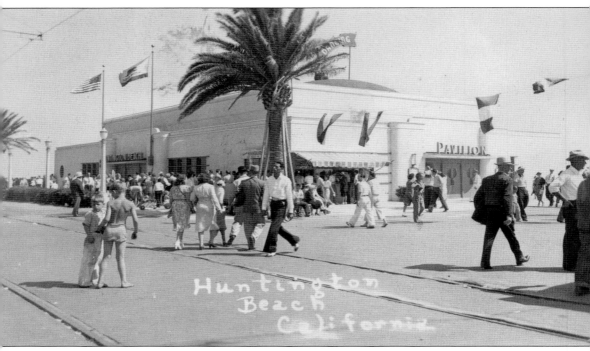

A bustling summertime crowd hovers outside the Pav-A-Lon Ballroom in the early 1940s. These were the days of big bands and swing music made popular by bandleaders such as Glenn Miller and Benny Goodman. Many of the most famous bandleaders of the day actually performed here at this ballroom.

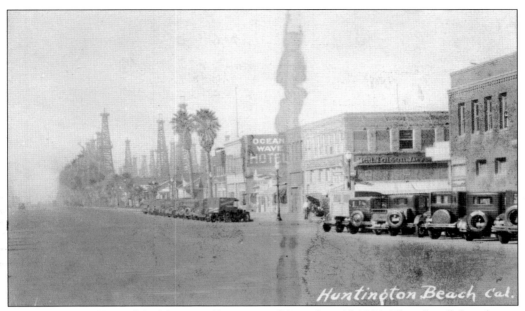

This is a damaged but still highly compelling postcard from the mid-1920s. The oil wells have begun to take over, and the Ocean Wave Hotel sits near the corner of Main Street and Ocean Boulevard.

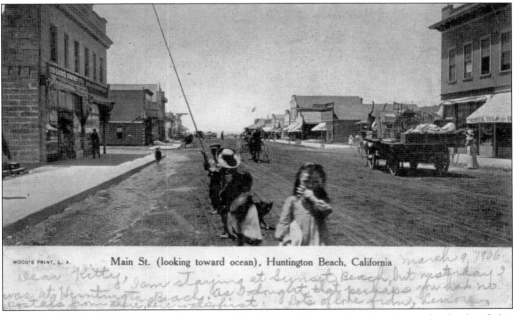

Postmarked March 11, 1906, and sent to Miss Kitty Allen in San Francisco, the back of this postcard reads, "Dear Kitty, I am staying at Sunset Beach but yesterday was at Huntington Beach. As I thought that perhaps you had no postals from there, here is the first. Lots of love from Lenore." This image is looking toward the pier.

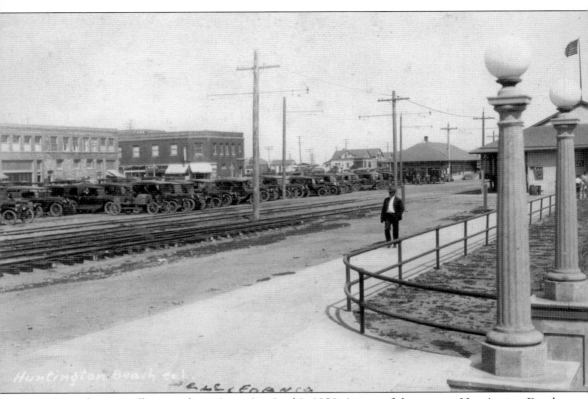

A gentleman walks near the train station in this 1920s image of downtown Huntington Beach. Note the competing modes of transportation that will change the landscape of the country in the coming decades.

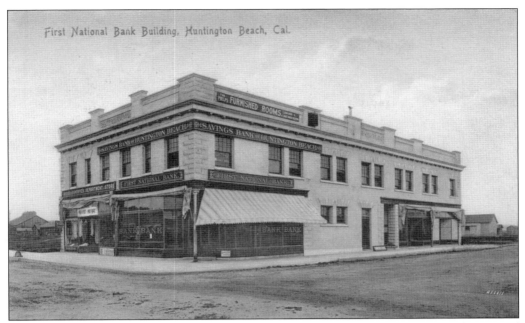

This postcard shows the First National Bank around 1910. Located on the corner of Main and Walnut Streets, the First National Bank Building was constructed in 1905. The storefront at the rear right corner was where the first city hall was located in 1909. Today a restaurant has replaced the classic old building.

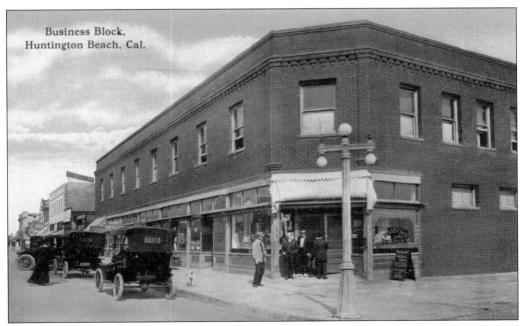

Described as the "Business Block" at Main Street and Ocean Avenue, this postcard is from around 1915. The year before, in June 1914, the newly dedicated Huntington Beach Pier entered the record books as the longest, highest, and only concrete pleasure pier in the United States.

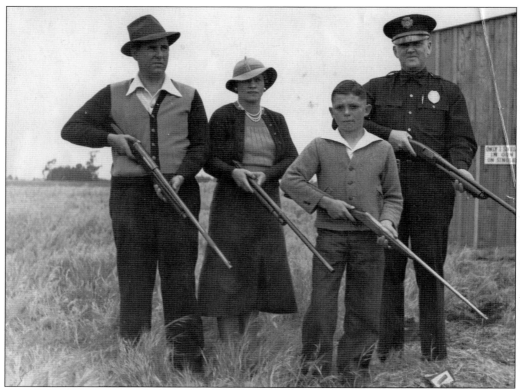

Dating back to the late 1890s, the Bolsa Chica Gun Club was located on a bluff that today is right by the Bolsa Chica State Beach and Bolsa Chica Ecological Reserve. The gun club was created by a group of wealthy businessmen from Los Angeles and Pasadena, and they built a two-story structure on the mesa overlooking the Pacific. The building was destroyed in the 1970s. Pictured here at the Gun Club around 1936 are, from left to right, Marcus McCallen, the onetime mayor of Huntington Beach and oil developer; Edna Cooper; Billy McCallen; and Les Grant, chief of the Huntington Beach Police Department during the mid-1930s.

This postcard of the Bolsa Chica Gun Club was painted by Dr. David Carlberg, a retired microbiologist who, in the 1970s, became one of the earliest Huntington Beach environmental activists. He served as president of the Amigos de Bolsa Chica, a group dedicated to protect local wetlands, and he remains deeply involved in the cause today. Dr. Carlberg is also the father of Marvin Carlberg, coauthor of this book.

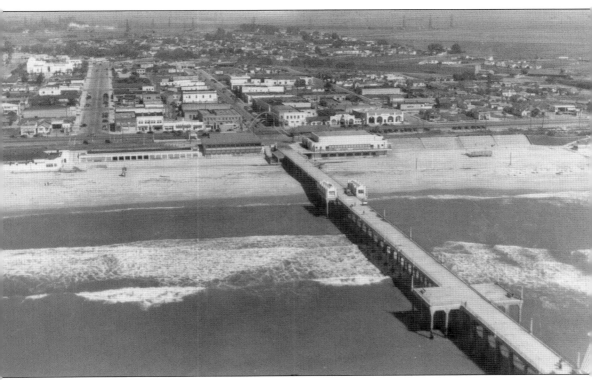

This wonderful aerial postcard from the late 1930s also features the Main Street arch. Oil wells dot the horizon, and beyond that is wide-open space. (Courtesy of Randy and Sharon Lynn.)

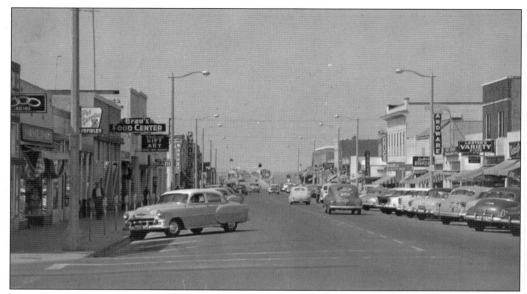

There is an interesting inscription on the back of this postcard postmarked February 2, 1951. It was sent to Los Angeles and reads, "Dear Penny, My name is Steve. I hope you get more postcards and I hope I do, too. Sincerely, Steve. PS, The front of this is the town of Huntington Beach where I live." Was there a postcard collection competition? Perhaps.

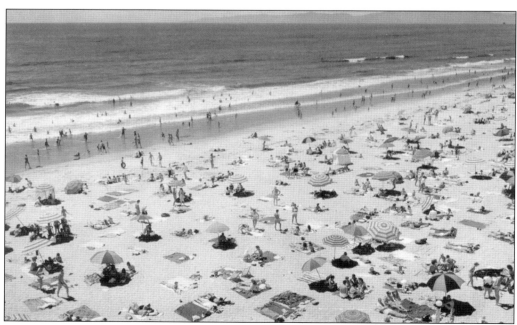

This Union Oil Company postcard from 1950 shows a typical day at the beach in Southern California that included swimmers, sunbathers, and bright umbrellas.

Main and Clay Streets adorn the front of this *c.* 1950 postcard. The caption on the back reads, "Visitors from inland Orange County communities who take Main Street into town are greeted by a beautiful parkway of geraniums, extending for quite a distance and usually a-blaze with color." What a charming memory.

ACROSS AMERICA, PEOPLE ARE DISCOVERING SOMETHING WONDERFUL. *THEIR HERITAGE.*

Arcadia Publishing is the leading local history publisher in the United States. With more than 4,000 titles in print and hundreds of new titles released every year, Arcadia has extensive specialized experience chronicling the history of communities and celebrating America's hidden stories, bringing to life the people, places, and events from the past. To discover the history of other communities across the nation, please visit:

www.arcadiapublishing.com

Customized search tools allow you to find regional history books about the town where you grew up, the cities where your friends and family live, the town where your parents met, or even that retirement spot you've been dreaming about.